photo·graphics

real world photo-graphic projects – from brief to finished solution

RotoVision ▶

ELECTRONIC WORKSHOP

A RotoVision Book
Published and distributed by RotoVision SA
Rue du Bugnon 7
CH-1299 Crans-Près-Céligny
Switzerland

RotoVision SA, Sales & Production Office
Sheridan House, 112/116A Western Road
Hove, East Sussex, BN3 1DD, UK

Tel: +44 (0) 1273 72 72 68
Fax: +44 (0) 1273 72 72 69
E-mail: sales@rotovision.com
www.rotovision.com

Distributed to the trade in the United States by:
Watson-Guptill Publications
1515 Broadway
New York, NY 10036

10 9 8 7 6 5 4 3 2 1

ISBN 2-88046-422-6

Book and Cover Design By Steven R Gilmore

Production and separations in Singapore by
ProVision Pte. Ltd.

Tel: +65 334 7720
Fax: +65 334 7721

RotoVision

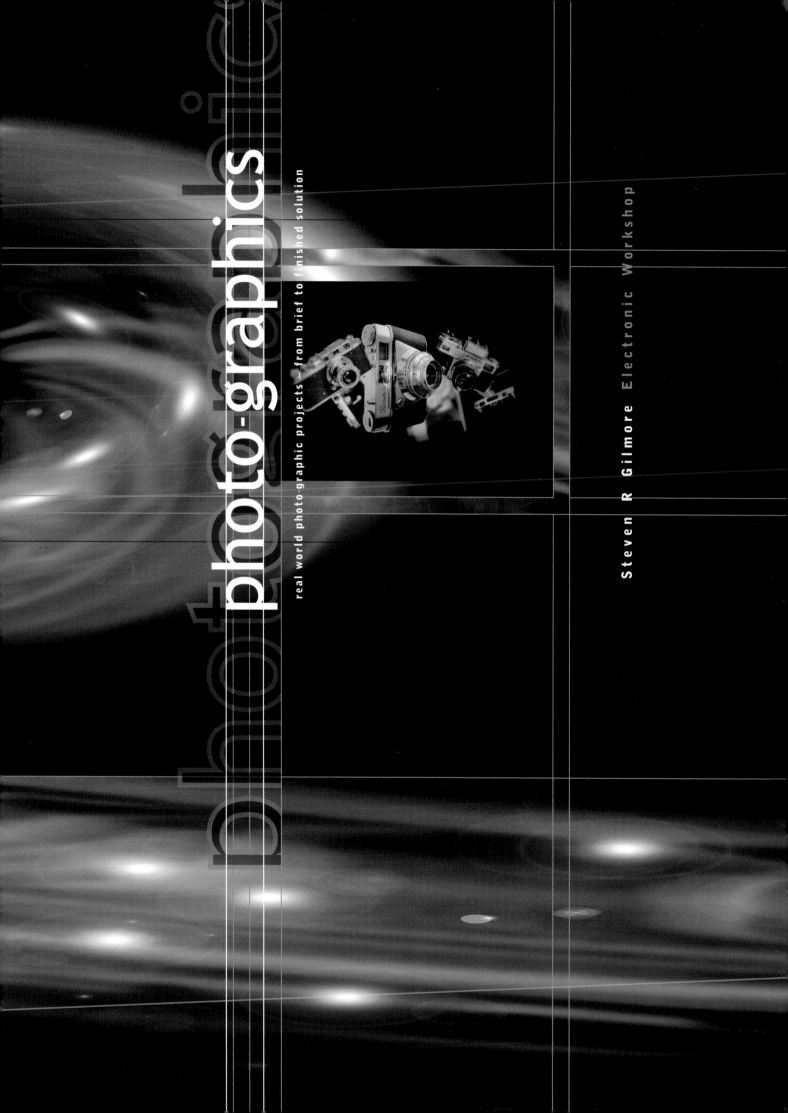

photo-graphics

real world photo-graphic projects — from brief to finished solution

Steven R Gilmore Electronic Workshop

contents

The contributors featured in this title encapsulate the international state of 'Photo-graphics' at the end of the twentieth century – 'Photo-graphics' meaning the digital manipulation of photography. Selected from the world's best, the 15 artists or groups of artists featured here have been chosen for their ability to break the boundaries of the photographic medium. In the quest for the perfect subject, advertising and editorial commissions have come to rely on a significant level of digital retouching. This style of perfection has led to further explorations, not only using photography to lend a 'realistic' edge to what is obviously an artificial surrounding, but also, unexpectedly, exploring what could only be described as 'low-brow' photography. The artists featured in this book are at the vanguard of these trends, using increasingly sophisticated technology to produce innovative and provocative work.

Ironically and perhaps unjustly, it is often not the photographer who will digitally modify his or her photographs; more often it is the designer or art director who uses the photography as a starting point to create a vision that the photographer may not have intended. This title uncovers more than just the process behind each piece of work; it illuminates the nature of the contributors, and the characteristics of their discipline. While some contributors were concerned that exposing their working practices to the public would take away the mystical appeal of their work, others were happy to detail exactly how each illusion was achieved. Each chapter concentrates on one or several projects by those featured and through text and images explores how the finished pieces came into being, from brief to finished artwork.

'Photo-graphics' reviews a discipline that has evolved in tune with technological advances and, as such, this discipline is essentially one of evolution; in order to practice it, the artist has to be amenable to change.

At the heart of all the work featured here is the creative drive that all true artists possess and the ability to transcribe that drive with the resources they have at hand. Although most of the contributors still work with traditional darkroom techniques, the computer has played an important role in exploring and enhancing their creative visions. In some cases it would have been impossible not to have used the computer. One thing that all the contributors have made clear is that the computer is not a substitute for creativity; without the ideas and the willingness to experiment it is just simply another tool.

Anthony Artiaga

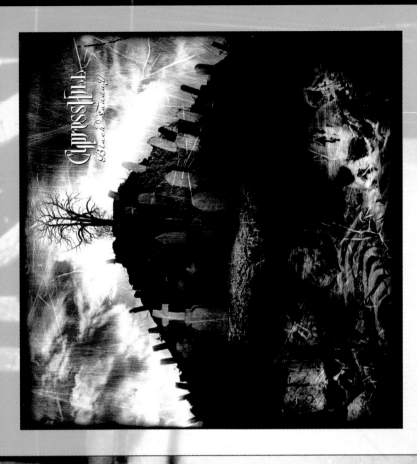

ANTHONY ARTIAGA was born in San Diego, California, and currently resides in Los Angeles working as a freelance photographer. His work has evolved image-making processes into powerful emotional, social and life-style statements. Artiaga's formal training in the arts had its genesis at the Skowhegan School of Painting and Sculpture in Maine, and continued at San Diego State University, where he obtained his Bachelor of Arts Degree in painting and print-making. Anthony attributes his success to his parents encouragement, perseverance and support. Anthony's father, a machinist by day, was also a musician and band leader with the Los Nuevos Latinos by night. His mother was a productive hobbyist, displaying artistic talent in ceramics. When Anthony displayed artistic tendencies at an early age, his parents encouraged his craft, and supported his education in the field. Artiaga's doodlings and caricatures at elementary school, having been well-received by his classmates, emboldened him to experiment with sketching and painting on canvas, as well as on less traditional surfaces. His paintings developed literal textures borrowed from the world of sculpture; and his subsequent works are characterized by a clever intermixture of diverse techniques and concepts.

Artiaga discovered that his wife, Robin Rose-Artiaga, a graphic designer, had intriguing software on her computer which could be used to duplicate, enhance, modify or conceptualize images derived from other media. The discovery of this software served to add to the effectiveness of the messages Artiaga was trying to achieve in any given project. Artiaga experiments with a number of mixed media and techniques utilizing painting, sculpture, photography and computer manipulations to create his unique images for clients including Sony Music, 'Rolling Stone' magazine, Warner Bros. Records, 'Newsweek' magazine, 'Ray Gun' magazine, Paramount Pictures, and Microsoft. Artiaga's work has received numerous awards as well as being honored with a Grammy nomination for his Oingo Boingo 'Boingo' CD sleeve design.

Artiaga has also directed music videos, and has shot both a full-length feature film and a short film in 16mm. His photographs have been exhibited at the Couturier Gallery and the Todd Kaplan Gallery, both in Los Angeles. He is currently working on his own self-financed short film while enthusiastically continuing with his commercial photography.

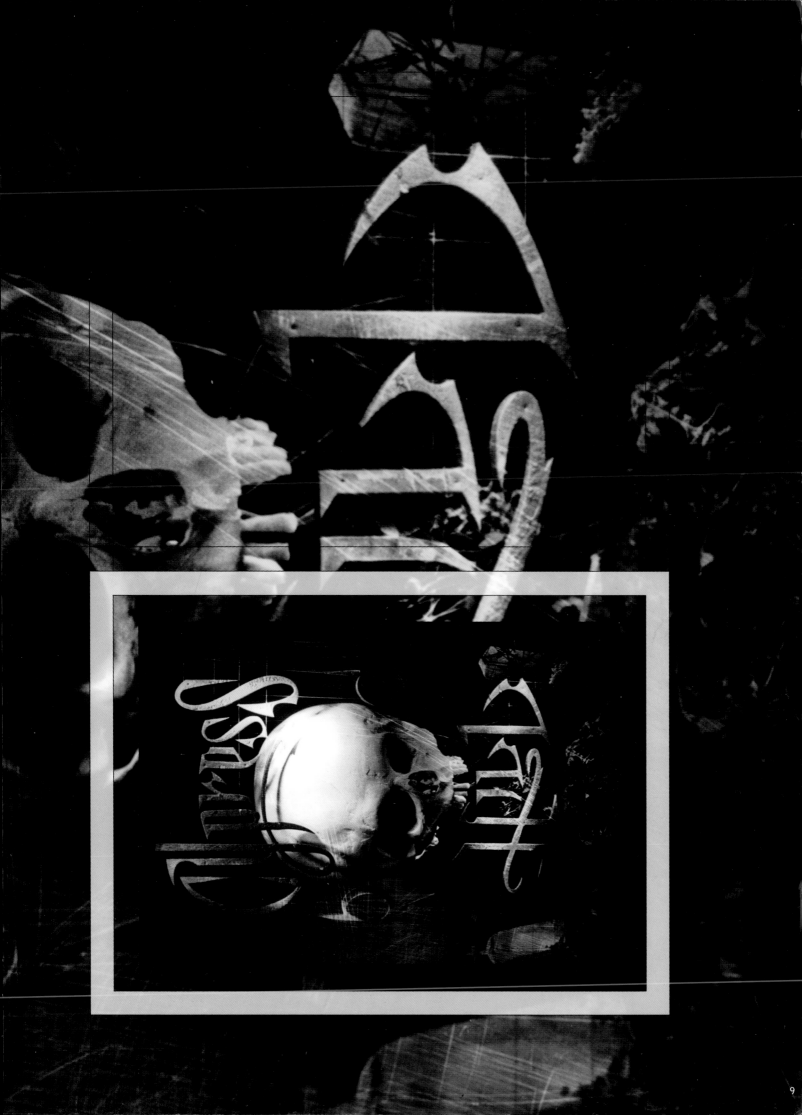

PROJECT ONE

Cypress Hill Black Sunday CD and Album Sleeve

Cypress Hill's art directors, Pawn Shop Press, approached Artiaga after seeing his award-winning images in the design publication 'HOW' – they managed to get hold of him by using a magnifying glass to enlarge his phone number on a self-promotional piece that was printed in the issue. The imagery that Artiaga created for this package reflects visual statements regarding the deadly consequences of gang violence which were voiced by Cypress Hill's DJ Muggs. Muggs envisioned a surreal cemetery with a lone tree on a hill serving as a guardian. Accompanied by Led Zeppelin blasting on the car stereo, Artiaga climbed a sign-pole on a busy New York City freeway to photograph the cemetery cited by Muggs as an influence. He recreated an impression of the cemetery as a miniature set in Los Angeles, integrating photographic elements such as a tree from the NYC cemetery and an ominous New Mexico sky later in the darkroom. Besides the main cover image Artiaga also shot several portraits of the band; this body of work would be used for all packaging, advertising, and merchandising products.

'The vision for Cypress Hill's album **Black Sunday** originated in a New York City cemetery.'

Artiaga built a miniature set for the front cover of 'Black Sunday' in his Los Angeles studio. His original idea for the sleeve featured a cutaway view of a woman buried under the tombstones, but when that idea was rejected for being too "creepy" he proceeded to meticulously sculpt a number of tiny skeletons and skulls which would end up being used on the finished cover. He combined the set photograph with the foreboding New Mexico skyline and a tree from a New York City cemetery later in the darkroom.

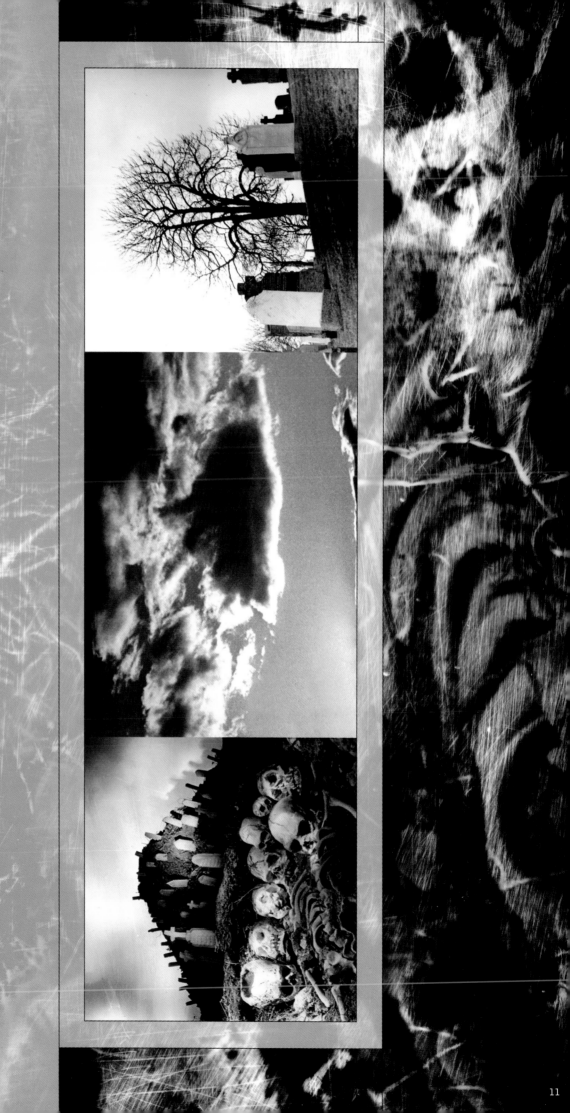

TECHNIQUE / KIT

The vision for Cypress Hill's multi-platinum selling album 'Black Sunday' originated in a New York City cemetery. Surrounded by thousands of dilapidated tombstones, Artiaga photographed the enormous melancholy environment. The impact of his surroundings spurred a clear vision for the final album cover. Artiaga shot with a Hasselblad 500C/M Camera and Zeiss 80mm f/2.8 lens on Kodak Tri-X Professional film (ISO 320). Exposure was f/60 seconds at f/8 with natural light provided at the cemetery. After returning to his studio in Los Angeles, he recreated a miniature set of a cemetery, originated with sculpted clay skeletal parts including several skulls. Not unlike Richard Dreyfuss's crazed mud-sculpting in 'Close Encounters Of The Third Kind', Artiaga removed portions of his lawn to create a dank subterranean feel for the set. He added garden soil, roots, weeds, and foam-core headstones aged with paint and Rembrandt Pastels. Once the set was completed Artiaga then placed his camera on a tripod, set the camera exposure to f/2.8 seconds at f/B using Kodak Tri-X Professional film (ISO 320) and photographed in complete darkness using only a flashlight as a light source to carefully highlight sections that were to be exposed on the film.

Artiaga developed the Tri-X film, using Kodak D-76 developer, stop bath, fixer and hydro-rinse. After the film had dried he then entered the darkroom ready to print the three photographic elements: the New York cemetery tree, a cloudy New Mexico sky and the miniature graveyard setting. All of Cypress Hill's photographic images were printed on black-and-white, double weight, glossy smooth white, hard contrast, Oriental New Seagull photographic paper grade G-3. Artiaga proceeded with the usual dodging and burning printing techniques. He emerged from the darkroom with several images which would be used for the cover of the album, then the elements were scanned and saved as 600 dpi Photoshop TIFF files. He composed the final collage together using the lasso tool for selecting, then feathering the elements. The final high resolution TIFF image was inverted to output to film as a black-and-white LVT digital negative. Once the final digital negative stage was completed, Artiaga returned to the darkroom again, adding scratches with sand paper and painting textures using black gouache on a clear piece of acetate. He placed the acetate directly over the virgin photographic paper in the darkroom then exposed the final print. After the final prints were chosen, he proceeded to bleach and sepia tone the paper.

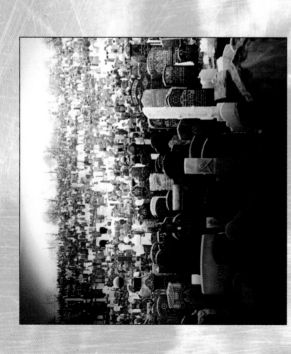

The 'Black Sunday' CD package highlights Artiaga's haunting portraits of each of the members of Cypress Hill: DJ Muggs, B Real, and Sin Dog. But it wasn't easy. Artiaga ventured to New York at the art director's request in order to shoot the portraits, but he only had a few tips from their record label on how to locate the band. With a little detective work, he found the threesome at another photographer's studio in Lower Manhattan, where 'Source' magazine were doing a shoot of the band. Because of their frantic schedules, and not a few blunts, Artiaga and the band had little time to shoot. Artiaga shot the portraits on a street corner while the 'Source' writer interviewed them for an article. This hectic pace helped in getting the type of portraits that Cypress Hill were after; they wanted their images to be indistinct and dark. The portraits were, shot with a Hasselblad 500C/M Camera and Zeiss 80mm f/2.8 lens on Kodak Tri-X Professional film (ISO 320). Exposure was f/125 second at f/16 with a Canon Speedlite flash. The portraits were textured as before, using sand paper and gouache on acetate. Again, they were further retouched and made sepia toned in Photoshop.

SIN DOG

B REAL

DJ MUGGS

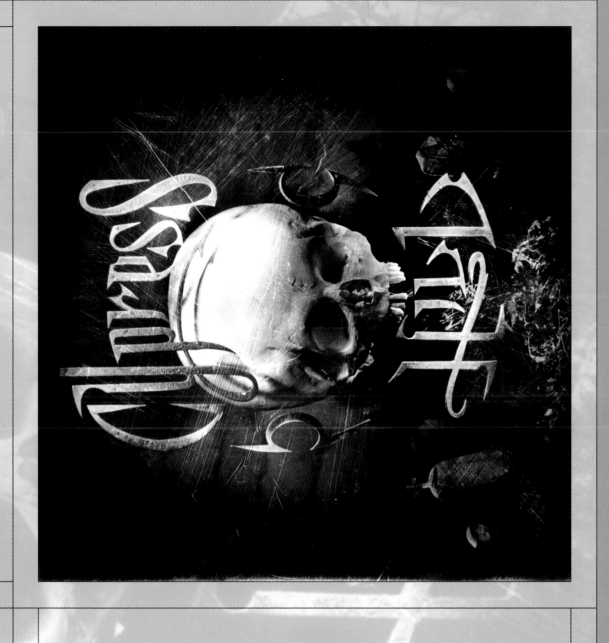

PROJECT TWO

Cypress Hill Insane In The Brain CD Single

The single release of 'Insane in the Brain' required additional front and back original photographic artwork from Artiaga. Having gained Cypress Hill's respect with 'Black Sunday', Artiaga was given free range in expressing his own ideas for the single sleeves that accompanied the album.

'For the most part, I prefer to work in complete darkness using only a flashlight for my light source.'

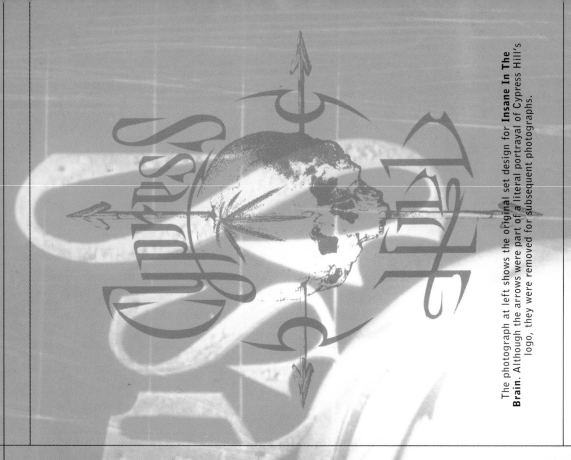

The photograph at left shows the original set design for **Insane In The Brain**. Although the arrows were part of a literal portrayal of Cypress Hill's logo, they were removed for subsequent photographs.

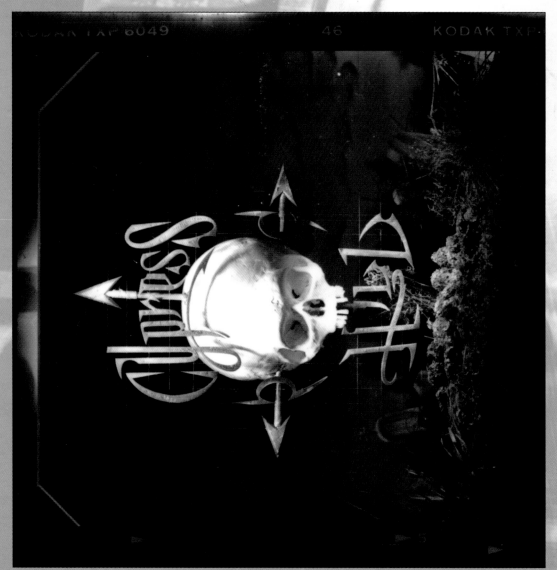

'Anyone can learn techniques, it's how you choose to use them that will make your work unique.'

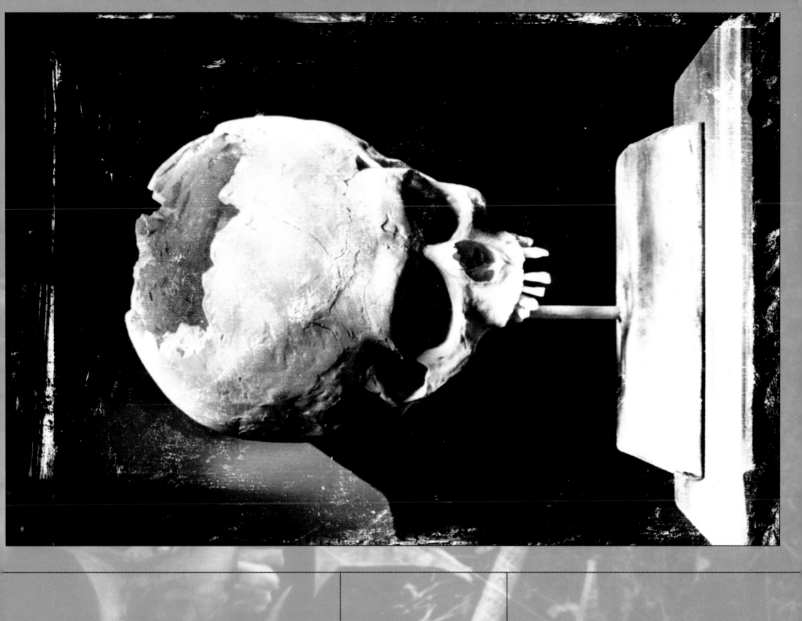

Artiaga conceptualized the sculpted transition of an encephalitis-inspired skull of ripeness and innocence on the front of the sleeve into a crudely lobotomized doom-pot featured on the back. Artiaga had to wade barefoot through bone-chips as well as endure the stench of burning cartilage caused by the carbide drill bit he used to open up the skull. The side effects of his handy-work still haunt him and prompted a temporary self-imposed boycott of the dentist's chair.

Pictured at right is the skull Artiaga "lobotomized".
At left is how it appeared on the back of the sleeve.

TECHNIQUE / KIT

Artiaga used a grid of fishing line to position a cardboard cut out of Cypress Hill's logo over the skull in the set, and later used the stamping tool in Photoshop to erase the fishing line. Once everything was in place, Artiaga locked down his camera on a tripod, exposure was f/2.8 seconds at f/B using Kodak Tri-X Professional film (ISO 320). Artiaga photographed the set in complete darkness using only a flashlight as his light source to highlight desired sections of the set. Artiaga developed the film and returned to the darkroom adding scratches, painted textures, bleach and sepia tone to the final print. This was then scanned into the computer, retouched and digitally output to negative film. The negative was then reprinted in the darkroom where further tones and effects were added.

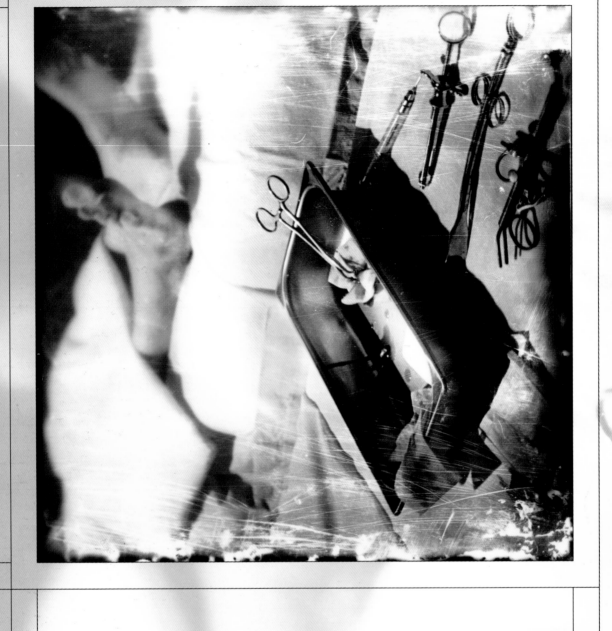

PROJECT THREE

Cypress Hill We Ain't Goin' Out Like That CD Single Sleeve

For the cover of 'We Ain't Goin' Out Like That' the art directors chose one of Artiaga's New York cemetery shots and simply added the band's logo and title. The challenge of this package was to create a literal representation of the earlier visual statements regarding the deadly consequences of gang violence featured on the first two sleeves. For this Artiaga recreated the tragic scenario of a victim undergoing surgery for a gun shot wound with the removed bullet and surgical tools looming in the foreground.

TECHNIQUE / KIT

Once the model was laying in the right position, Artiaga set his camera on a tripod, exposure was f/2.8 at f/B, with Kodak Tri-X Professional film (ISO 320). As with the previous photographs the lights were turned off, then he proceeded to photograph in complete darkness using only a flashlight as a light source for highlighting sections that were to be exposed to the negative. Artiaga developed the film and returned to the darkroom adding scratches and painted textures to a number of prints. After the final prints were chosen, he proceeded to bleach and sepia tone the paper. The images were then scanned into the computer where he used Photoshop for additional retouching and to fine tune the sepia tone effect. The upper right photograph was the final image chosen for the sleeve.

'The photography reflects visual statements regarding the deadly consequences of gang violence.'

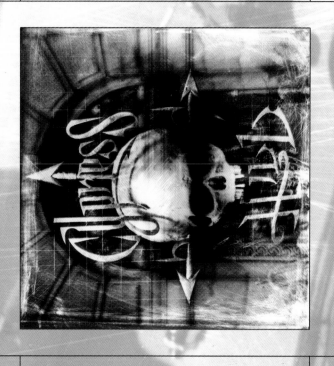

SOFTWARE (Print):

Adobe Photoshop 2.5 / 3.5
Macromedia FreeHand 7.0 / 7.1
Adaptec Toast 3.5

HARDWARE (Computer):

PowerMac G3
Optiquest 19" Monitor
6 gig Hard Drive
System 8.0
160 megs of RAM
AGFA Arcus II Scanner
Iomega Zip Drive
Sony Spressa CD Recorder
Epson Stylus Color 800

HARDWARE (Photography):

Hasselblad 500C/M Camera
Nikon N2000 Camera
Several different lenses
Polaroid 195 Land Camera
Omega Universal Pro Lab Photo Enlarger

Anthony Artiaga
10644 Hatteras Street
North Hollywood, California
91601 USA

Telephone: +1 818 505 0849
Fax: +1 818 760 4231
E-Mail: artiagarose@worldnet.att.net.

SEE PAGE 143

Client List:
Sony Music, 'Rolling Stone' (USA),
Warner Bros. Records, 'RayGun' (USA),
Paramount Pictures, Microsoft.

MARGO CHASE'S style, which uses complex layering and unusual letterforms, comes from a love of history and a willingness to challenge accepted ideas about contemporary design. 'Although I love to make things that look beautiful at first glance, if I can create a second conversation below the surface it gives resonance to the piece. All contemporary design has some connection to history. History has given us a vocabulary of symbols that we can use and adapt to communicate new ideas. Drawing on these symbols and recognizing that this second conversation is taking place gives my work a subtext and allows me to play with the layers of meaning that result,' says Chase.

Chase is the owner/principal of Margo Chase Design, a multidisciplinary design studio based in Los Angeles. Chase graduated from college with a degree in Biology and Medical Illustration. This unconventional design education combined with a love of letterforms, gothic architecture and medieval manuscripts may explain the organic approach to design that has been her trademark.

Her studio has created unconventional design solutions for consumer packaging, corporate identity, feature film advertising, environmental graphics, books, products, motion graphics and interactive multimedia. Over the past 11 years Chase has created award-winning cover art for Madonna, Prince, Bonnie Raitt and movie posters including Francis Ford Coppola's 'Dracula'. Her studio has a long roster of prestigious clients such as TBWA Chiat/Day, Goodby Silverstein, Leo Burnett USA, Columbia Pictures, Paramount Pictures, Warner Bros., Nike, Reebok, Virgin Interactive and Chronicle Books.

They have recently begun work on the overall creative re-orientation of a luxury home textiles company called Matteo Home. The studio is responsible for all aspects of Matteo's design and marketing including identity, packaging, exhibition and product design.

Their current print, video and web projects, along with their recently launched digital font foundry, Gravy Fonts, keep their small group of four extremely busy. For the future they're planning to focus more on the design of products they conceive, design and market themselves. They have several new products in the works that they try to fit in around their daily schedule.

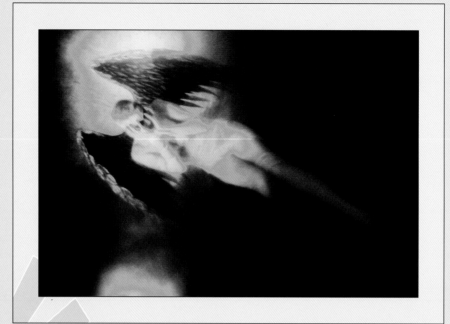

THE PROJECT and DEVELOPMENT

G(O)OD and (D)EVIL Posters

Margo Chase has always been fascinated by the dualities in spiritual and psychological symbolism which reflect the nature of man. 'The epic battle between good and evil has been a favorite theme of religious art through the centuries and although we might find the idea of angels and devils a bit quaint today, our struggle for balance between irreconcilable opposites still finds expression in every aspect of our lives and art,' says Chase.

This pair of posters is a send-up of the moral and religious themes of good and evil and is part of a promotional series based on the theme of opposites. Merlyn Rosenberg photographed the angel and devil several years ago. The angel was an out-take from a CD cover shoot which Chase and Rosenberg creatively collaborated on for a band called 'Ten Inch Men' (left). The devil was shot later with a plan to use the pair together. 'These images have stuck with me for years,' explains Chase. 'The idea of God as the ultimate good and the Devil as the ultimate evil is such an oversimplification that it gives Merlyn's powerful photographs an even more sinister edge,' she concludes.

Project Credits:

Photographs: Merlyn Rosenberg
Art Direction and Design: Margo Chase

The insets above and on the previous page show Rosenberg's photographs before being digitally manipulated.

'The computer adds a huge degree of flexibility to creating designs that incorporate photography.'

TECHNIQUE / KIT

These posters were created by using a variety of software and techniques. Rosenberg shot the original photos on 35mm transparency film that was cross-processed in C-41 chemistry. The resulting prints were drum-scanned at a service bureau. She then proceeded to manipulate the color channels of the scans in Photoshop to create a posterized color effect. Chase sketched the type and cartoon heads by hand, scanning them into the computer using a flat-bed scanner. Using the scans as background templates, Chase drew the final artwork in Adobe Illustrator. These vector files were then imported directly into Photoshop for the flat letters and into Cinema 4-D to create the 3-D renders. After creating the final 3-D renders, she imported them into Photoshop layering them with textures from Rosenberg's photos to achieve less of a digital effect. The striated lines were created by converting sections of the photos to bitmap halftone files using the "lines" screen and then using the results as channels in Photoshop.

As illustrated on the next page, Chase went through several incarnations of the composition of these posters in Adobe Illustrator before deciding on the final versions. To get the proportions correct she then imported the appropriate parts into Adobe Photoshop to use as guides in building the final composites.

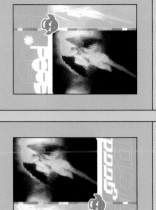

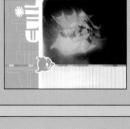

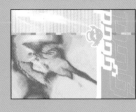
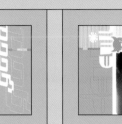

WORKING WITH PHOTOGRAPHY

'I have always been seduced by the authenticity inherent in a photographic image. If it's a photograph it MUST be real. Playing with this supposition of reality can give a piece of design a surreal power that illustration or type alone lacks. I am always drawn to images that have several layers of meaning, and I like to work with photographers who can convey that vision in their work. I'm not drawn to pure reportage. I much prefer ambiguity or overt symbolism to simple reality. I am also fascinated by the way that meaning can change with context. Placing certain images in juxtaposition with each other or with certain styles of typography can completely change the way that the image alone might be interpreted. This is the power that the designer can bring to photography and it's the intangible element that's present in great photographic design,' says Chase.

'In addition to those created by talented photographers, many of the design pieces I create contain photographic images that I shoot. These images are often textures or backgrounds that are manipulated digitally to add dimension to a piece. Sometimes they're dimensional interpretations of lettering or other graphic elements that take the design into three-dimensional space. I tend to feel less guilty about "ruining" some great photographer's work by digitally manipulating it when the original image is my own,' Chase adds.

'The computer adds a huge degree of flexibility to creating designs that incorporate photography. When I first started working as a designer, any image I wanted to manipulate required an immense amount of work by outside people – photolabs, retouchers and strippers – to get the results I wanted. When I first got a computer I was worried that the results I was used to couldn't be reproduced digitally. Was I wrong! The Mac has allowed me to explore entirely new areas of design and incorporate photographic images in ways I never dreamed of before. In addition to manipulating just the photographic image, I have been able to add typography to images and incorporate illustrations and other graphic elements into the final pieces. This flexibility has recently extended to creating 3-D type and images completely on the computer and combining these with photographic images and textures. The blatant artificiality of these digitally created images adds yet another layer of meaning to a piece and can create a strong counterpoint to the "reality" of a photographic image,' concludes Chase.

Final **G(O)OD** Poster

Final **(D)EVIL** Poster

'Our struggle for balance between irreconcilable opposites still finds expression in every aspect of our lives and art.

HARDWARE (Print):

PowerMac 9500/132 with G3 Accelerator
320 megs of RAM
8 gig External FWB Sledgehammer Hard Drive
21" Mitsubishi Monitor

HARDWARE (Video):

PowerMac 9600/300
730 megs of RAM
Media100 XS Video Board
2 gig Jaz Drive
Sony NTSC Monitor

HARDWARE (Camera):

Minolta ActionCam Digital Camera

SOFTWARE (Print):

Adobe Photoshop 5
Illustrator 8
QuarkXPress 3.32
Fontographer 4.1

SOFTWARE (Video/interactive):

Adobe AfterEffects 4.0
Media 100 XL 4.0
Adobe Premiere 4.0
Macramedia Director 6
Shockwave Flash 3.0

SOFTWARE (3-D):

Cinema 4-D
Infini-D 4.0

Margo Chase Design
2255 Bancroft Avenue
Los Angeles, California
90039 USA

Telephone:. +1 323 668 1055
Fax: +1 323 668 2470
Website: www.margochase.com

SEE PAGE 144

Client List:
Columbia Pictures, Paramount Pictures,
Warner Bros., Nike, Reebok, Adobe Systems,
The Hard Rock Hotel, Microsoft Network.

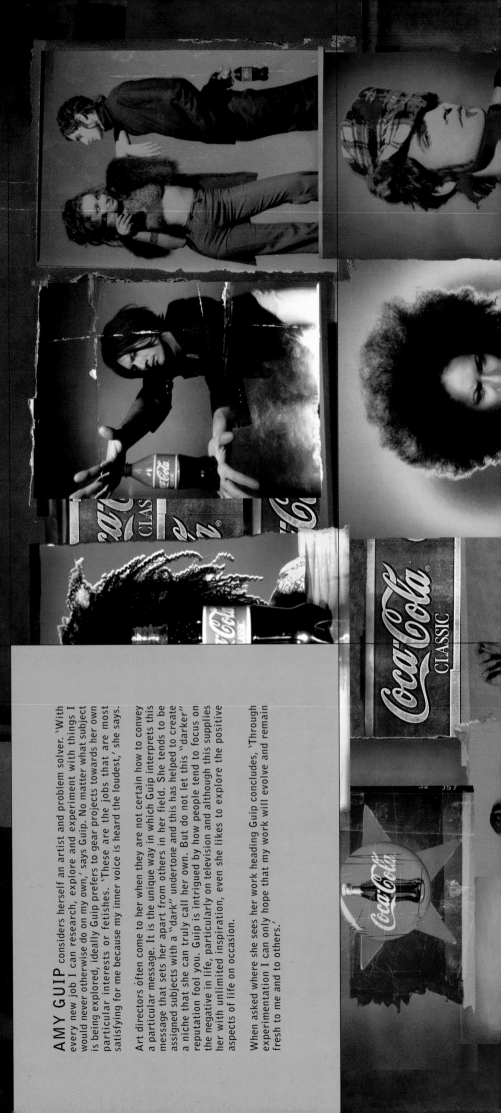

AMY GUIP considers herself an artist and problem solver. 'With every new job I can research, explore and experiment with things I would never otherwise do on my own,' says Guip. No matter what subject is being explored, ideally Guip prefers to gear projects towards her own particular interests or fetishes. 'These are the jobs that are most satisfying for me because my inner voice is heard the loudest,' she says.

Art directors often come to her when they are not certain how to convey a particular message. It is the unique way in which Guip interprets this message that sets her apart from others in her field. She tends to be assigned subjects with a "dark" undertone and this has helped to create a niche that she can truly call her own. But do not let this "darker" reputation fool you. Guip is intrigued by how people tend to focus on the negative in life, particularly on television and although this supplies her with unlimited inspiration, even she likes to explore the positive aspects of life on occasion.

When asked where she sees her work heading Guip concludes, 'Through experimentation I can only hope that my work will evolve and remain fresh to me and to others.'

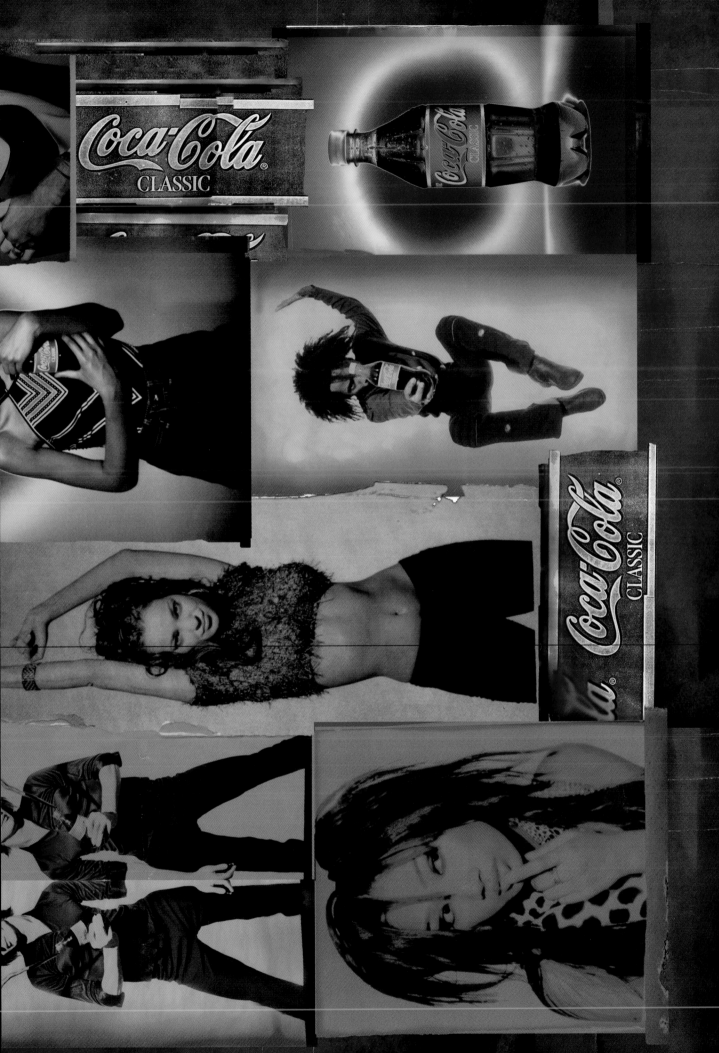

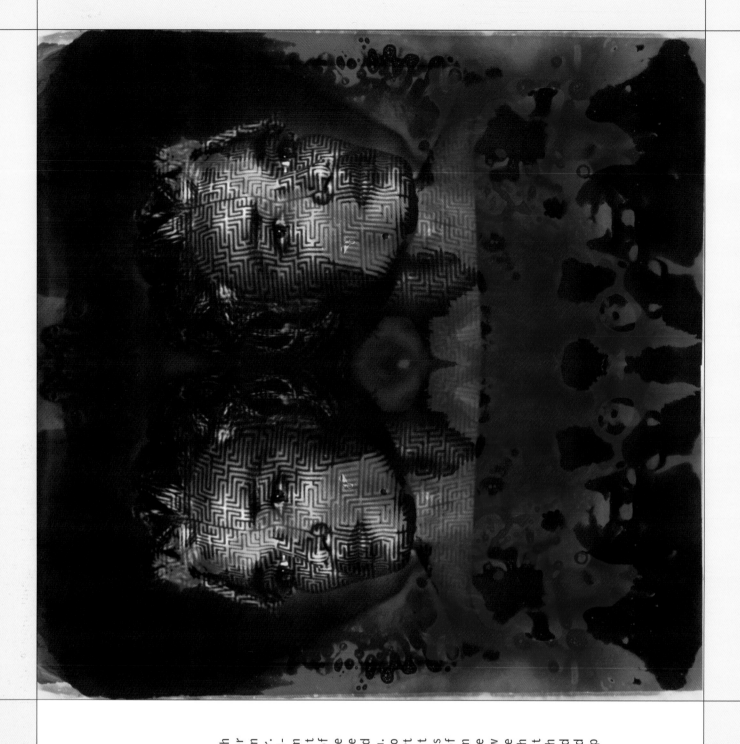

PROJECT ONE

Flamma Flamma CD Cover

DEVELOPMENT

This opera explores facing death, death ceremonies, life and fire. The composer was interested in incorporating an image of a labyrinth into the cover. With these things in mind, Guip pencil-sketched some ideas and showed them to the client. The client was most interested in her idea of an image of an androgynous person with a maze projected on their face. This image symbolized a person facing and exploring the puzzling journey of death. 'The labyrinth projection was a way to show that the maze was already a part of this person, literally right in front of them, but hard to truly see,' says Guip. The client also liked her idea of a person with a white dove sitting on their head along with a mirrored image of the same person with a black crow on their head. To Guip, the dove symbolized life, and the crow, which was not merely sitting on the head but was tightly tied down, symbolized death – a reality which we will all be forced to face at some point. With a good amount of faith, this client left Guip alone, "to do her thing".

Project Credits:

Photography and Artwork: Amy Guip
Hair and Makeup: Eva Scrivo
Art Direction: Julian Peploe

'There are so many wonderful spontaneous things that happen in a shoot that can never be preconceived and comped.'

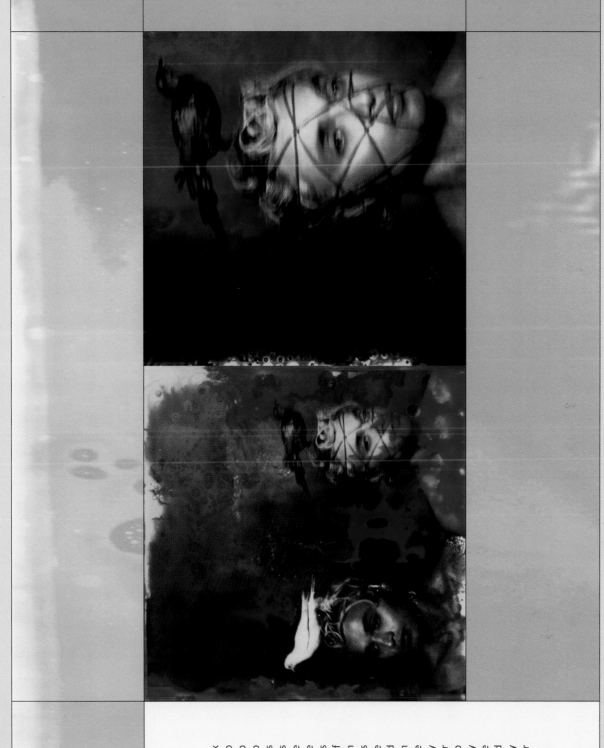

TECHNIQUE

Guip wanted the hair and makeup to look mythological, somewhat like a marble statue. To achieve this effect white makeup was applied to the hair and the model's face was powdered. To create the maze effect, Guip made slides of mazes and projected them directly onto the model's face. Then the birds were simply placed on the head and photographed. To reflect the title 'Flamma Flamma,' Guip toned parts of the prints with orange toner to create a subtle feeling of fire. In Photoshop, she took the maze shot then mirrored and seamlessly blended the two halves together. By blending the halves Guip feels the image took on a more iconic feel and she liked the way the orange toner took on a Rorschach Test look. The bird photographs were a little more difficult to blend together because they were two different shots. Without the computer her ideas still could have worked by butting two photos against each other, but the seamless quality she was able to achieve with Photoshop gave the pieces a more dreamlike feel. Guip also supplied the client with an option of the black bird by itself but they eventually chose the maze shot for the final artwork.

'I must always warn my clients to expect a considerable number of changes and to view comps simply as indications of feel and attitude.'

PROJECT TWO

Coca-Cola Advertisement

Project Credits:
Photography and Artwork: Amy Guip
Hair and Makeup: Eva Scrivo
Stylist: John Moore
Creative Direction: David Stevensen

THE BRIEF

The ad agency McCann Erickson were familiar with the Broadway musical 'Rent' along with the imagery that Guip had created for it. 'The creatives from McCann Erickson wanted to tap into the popularity of the show and the intensity of the show's advertising campaign and use it for Coca-Cola,' says Guip. Guip was asked to create a series of images representing each of the four seasons. Although Guip has been creating imagery in the style of 'Rent' for years she was uncomfortable repeating the same "look" for Coca-Cola because it was so strongly associated with the show. David Stevensen, the creative director at McCann Erickson, assured Guip that her work for Coke would look different because of the themes of the seasons, as well as the different colors and props that would make the campaign unique.

DEVELOPMENT

The ad agency insisted Guip do tight proposals before shooting. Guip always finds this difficult because she is restricted to using existing photography, whether it be her's or someone else's. 'Pencil sketches of collaged pieces are just something that never work that well in advertising,' says Guip. Creative and art directors are trained to visualize the end result of a sketch, but for the most part, their clients are not. Although Photoshop makes it so easy to pull together a proposal and make it look finished, at times this can also have a negative effect. The client can perceive these proposals as pieces that are ready for press and expect the finished results to look exactly the same. 'There are so many wonderful spontaneous things that happen in a shoot that can never be preconceived and comped,' adds Guip. Guip tries to warn her clients to expect a considerable number of changes to her proposals and to view them simply as indications of feel and attitude. With difficult clients she will even go so far as taking a tight Photoshop color proposal and photocopy it in black and white or even run it through a fax machine to destroy the quality before sending it off. This ensures that they won't get too involved in the details.

fall

summer

spring

winter

Guip's seasonal proposals for **Coca-Cola**

Guip's work for the Broadway Show 'Rent'

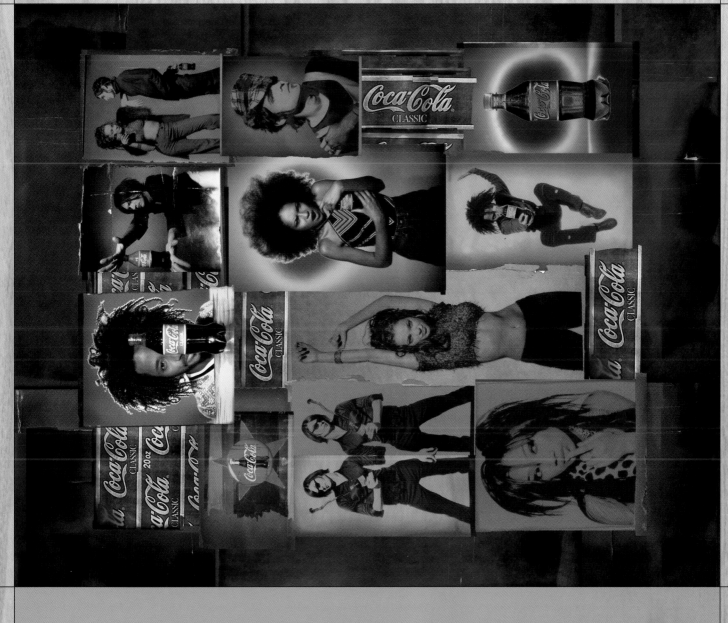

Guip chose a different color palette and an object or two for each of the season proposals. She felt confident that this new work would have the same energy and vitality as the 'Rent' piece but would become its own unique statement. The client, however, decided that they wanted to start with the fall color palette which most closely resembled 'Rent.' Because McCann didn't want to venture far from the 'Rent' piece, Guip talked to her representative and had the McCann Erickson legal department draw up a contract stating that she was not liable for any potential legal problems that might arise for creating a look similar to 'Rent'. 'Isn't it ironic that I would have to protect myself from ripping off my own look,' muses Guip.

After getting the legalities out of the way the shoot went rather smoothly. Guip shot seven people in as many different styles and set-ups as humanly possible, all in a single day.

TECHNIQUE

Guip started by printing the photos in the darkroom as she had with the 'Rent' piece (there was no digital technology used for 'Rent'). After printing and toning, she collaged the prints together by loosely taping them onto a board so the client could visualize it as one piece. After approval, the collage was broken apart and the individual photos were scanned by a service bureau. Using Quark, the design firm put the collage back together exactly the way Guip had designed it. The photos needed to be used in a variety of applications, from magazine ads and subway ads to the original poster; for this reason a glued-down collage would have been impractical. Only one final piece was needed for the Coke ad, however, so she chose to create it in Photoshop, which she says was much more proficient in since the 'Rent' campaign, Guip used Photoshop to create a different palette: 'As subtle a difference as it may be,' adds Guip. Photoshop also allowed her to resize, flop and crop any photo, 'which loosened me up quite a bit compositionally,' she concludes.

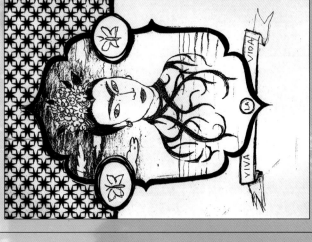

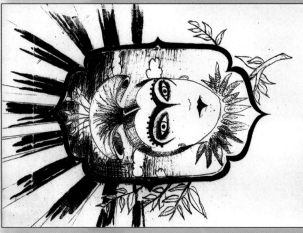

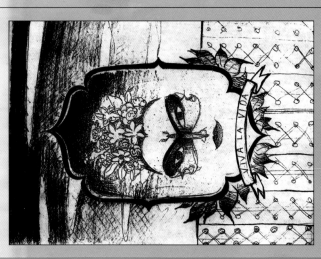

PROJECT THREE

Levi's Poster

THE BRIEF

Morla Design was hired by Levi's to choose different artists to create a series of posters on women. It sounds too simple to be true, but if there was more behind it, they did not pass that information onto Guip. The only direction she was initially given was that they wanted her to use an abundance of different patterns which they had seen in her portfolio.

DEVELOPMENT

'I love the way women adorn themselves in different cultures. I also love the way nature adorns certain animals with color and pattern. I wanted to meld the two,' says Guip. One of her ideas was to combine the eyes of a woman with the wings of a butterfly to give the illusion as if the eyes were part of the pattern in the wings. Another idea was to do the hair and makeup like a bird, turning the lips into a beak and adorning the model with feathers. Guip has a fascination with hair so she also presented a sketch of a woman whose hair wrapped around her body so completely that it created the shape of her figure making her flesh practically disappear. She is not quite sure what the meaning is behind this idea, it is just something that intrigues her. At this point Morla Design presented their own interpretations of Guip's ideas. They saw an underlying Indian influence in one of her proposals and had her re-sketch a woman in Indian dress and ornamentation. 'For a project that started out supposedly being an open interpretation of the artist, things started to change fast,' adds Guip. Although Guip was discouraged by the agency's input she wasn't completely disappointed because she has always been intrigued with the art and imagery of India. To make sure she could still put her own twist on their ideas she proposed that she photograph the woman in traditional dress, as they wanted, and also create an image of the hair idea to satisfy herself. Before shooting, she received a package from Morla Design that not only indicated the color palette they wanted her to use, but also showing her an example of another artist's work they wanted her to imitate. 'The word "shocked" comes to mind,' remembers Guip.

Project Credits:

Photography and Artwork: Amy Guip
Hair and Makeup: Eva Scrivo
Art Direction: Angela Williams

'For a project that started out supposedly being an open interpretation of the artist, things started to change fast.'

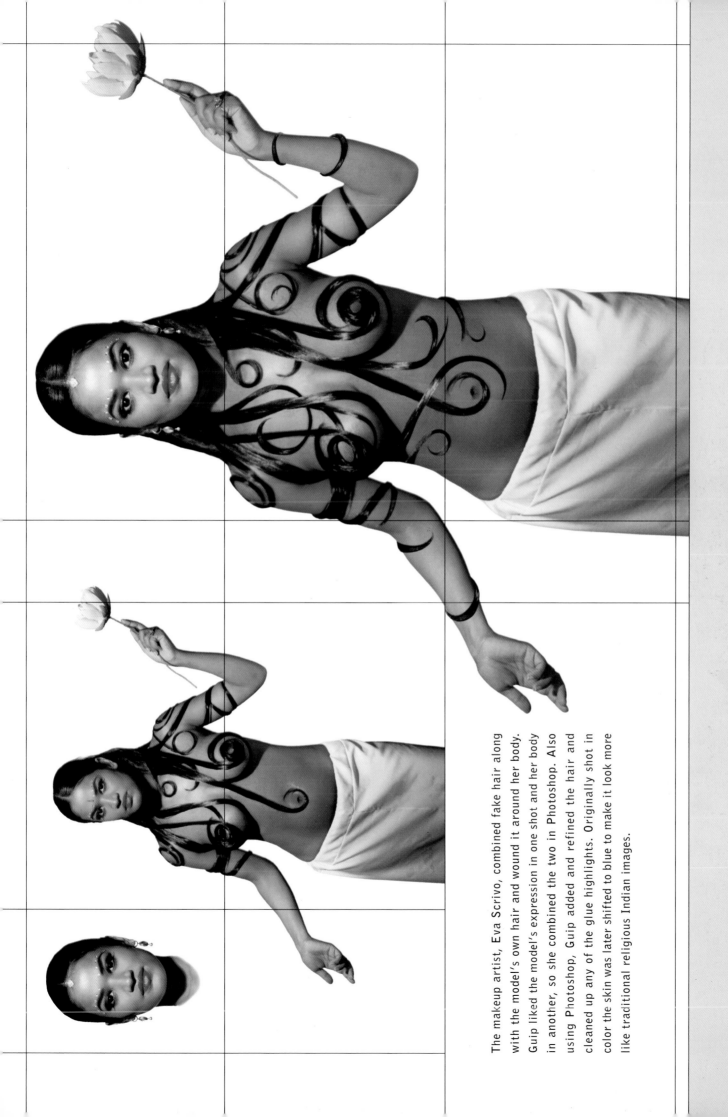

The makeup artist, Eva Scrivo, combined fake hair along with the model's own hair and wound it around her body. Guip liked the model's expression in one shot and her body in another, so she combined the two in Photoshop. Also using Photoshop, Guip added and refined the hair and cleaned up any of the glue highlights. Originally shot in color the skin was later shifted to blue to make it look more like traditional religious Indian images.

'The technology that enabled me to even fathom that I could create some of these ideas also hindered the final image.'

33

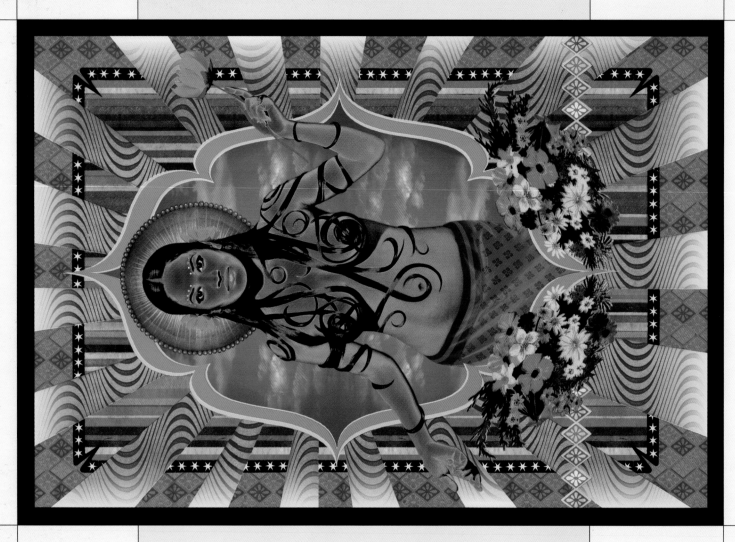

TECHNIQUE

Besides the techniques mentioned on the previous page, the patterns featured on the finished artwork were created from many different resources, with the colors being altered in Photoshop until Guip achieved the desired effect. A pattern was also added to the model's skirt.

Because of the large file size – creating an image for a poster in Photoshop is difficult – Guip decided to minimize the size by creating a smaller image, 7.5 x 11" at 762 dpi, in RGB mode which could then be output as a 4 x 5" transparency. This size ensured there would be no pixels visible once it was enlarged to poster size. At the time, Guip's computer was considered rather powerful, but with the number of layers this artwork required the file size grew upwards to 700 megabytes, causing painfully slow screen redraws. This compromised her creative decision-making; 'because of deadline pressures, I would be intimidated to try something new because of the time involved with a simple function,' recalls Guip. 'The technology that enabled me to even fathom that I could create some of these ideas also hindered the final image,' she adds. Her computer can now handle this workload much easier but because we expect so much from our machines she is sure there will be other hurdles to overcome in the future.

SOFTWARE (Computer):

Adobe Photoshop 4.0/5.0
QuarkXPress 4.0

HARDWARE (Computer):

PowerMac G3
Power Macintosh 8500
Micronet 4000 and 2000 Hard Drives
Viewsonic 13" and 21" Monitors
Rasterops 21" Monitor
Lacie CD Writer
Micronet CD Writer
Epson 3000 Printer
Hewlett Packard Laser Jet Printer
Epson 836XL Scanner
Epson Stylus Color 800
Iomega Jaz and Zip Drives

Alternative version of **Flamma Flamma** CD Cover

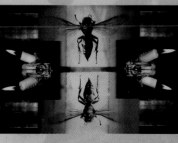

Amy Guip
91 East 4th Street, 6th Floor
New York City, New York, 10003 USA

Telephone: +1 212 674 8166 Fax: +1 212 674 2775
E-mail: guip@earthlink.net
Representative: Kathleen McCormack at AKA Reps
Telephone: +1 212 620 4777 Fax: +1 212 620 4888
E-mail: akareps@earthlink.net

SEE PAGE 145

Client List:
Coca-Cola, Reebok, Nike, Levi's, IBM,
MTV Networks, Showtime, 'Time' magazine (USA),
Random House, Sony Music, Warner Bros. Music.

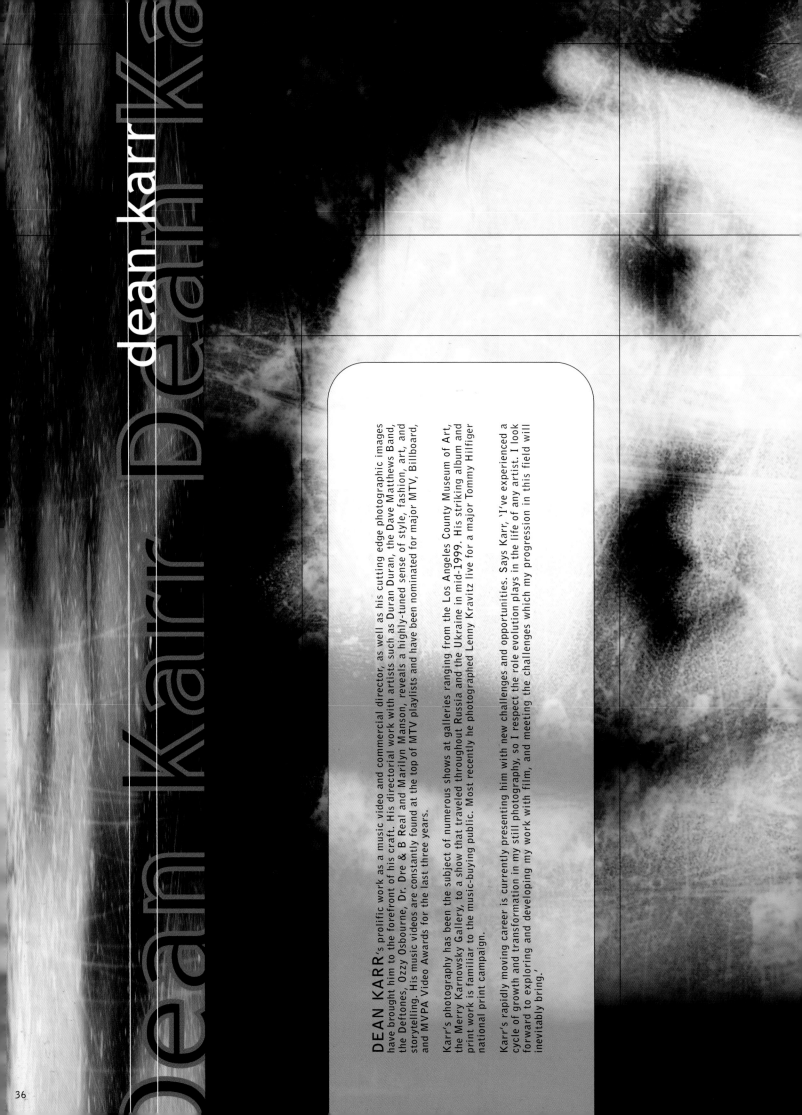

dean karr

DEAN KARR's prolific work as a music video and commercial director, as well as his cutting edge photographic images have brought him to the forefront of his craft. His directorial work with artists such as Duran Duran, the Dave Matthews Band, the Deftones, Ozzy Osbourne, Dr. Dre & B Real and Marilyn Manson, reveals a highly-tuned sense of style, fashion, art, and storytelling. His music videos are constantly found at the top of MTV playlists and have been nominated for major MTV, Billboard, and MVPA Video Awards for the last three years.

Karr's photography has been the subject of numerous shows at galleries ranging from the Los Angeles County Museum of Art, the Merry Karnowsky Gallery, to a show that traveled throughout Russia and the Ukraine in mid-1999. His striking album and print work is familiar to the music-buying public. Most recently he photographed Lenny Kravitz live for a major Tommy Hilfiger national print campaign.

Karr's rapidly moving career is currently presenting him with new challenges and opportunities. Says Karr, 'I've experienced a cycle of growth and transformation in my still photography, so I respect the role evolution plays in the life of any artist. I look forward to exploring and developing my work with film, and meeting the challenges which my progression in this field will inevitably bring.'

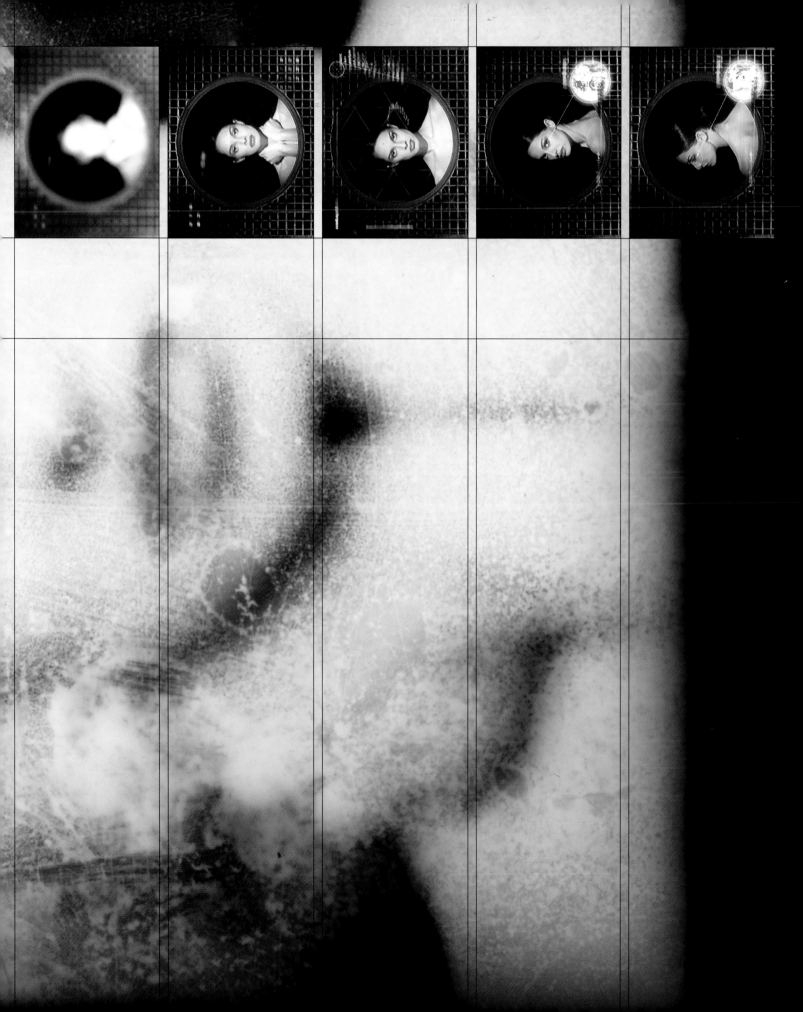

KODAK EPN 6058

THE PROJECT

HOW IT MEASURES

A 30 second television commercial spot Dean Karr directed for the Mazda 626 automobile.

BACKGROUND / BRIEF

Karr was approached by the Foote, Cone and Belding agency in San Francisco (through his then production company RSA/Blackdog) to direct the new Mazda 626 commercial 'How It Measures'. His spot was a wild card which the agency was having trouble wrapping their heads around, so Karr was brought into the equation to help in the problem solving. Karr flew to San Francisco on an hour's notice and went to the home of the creative director Corey Stolberg, agency producer Bob Gondell was also there for the meeting. Karr did a series of loose sketches which helped everyone involved to visualize his proposal of the marriage of film, motion graphics and photography into one medium. It was important to Karr for the 'How it Measures' spot to retain the organic and abstract feeling of his photography, as well as connecting the clinical representation of the beautiful woman together with sensually lit parts of the car's engine and its lines.

The client was aiming for a female audience between 25 and 35 years old for this commercial spot. Says Karr, 'I felt that the spot, without a doubt, had an attractive hook for that audience. The commercial had a long run on the networks and really stood out as something fresh.'

Project Credits:

Director/Photographer: Dean Karr (now of 'A Band Apart' formerly of RSA/Blackdog)
Producer: Arthur Gorson (now of 'A Band Apart' formerly of RSA/Blackdog)
Director of Photography: Joseph Yacoe (Mack/Dolian Agency)
Motion Graphics Designer: Erik Bertellotti (The Perhapsatron Corp.)
Editor: Hal Honigsberg (Red Car)
Set Designer: Patrick Sherman (Mack/Dolan Agency)
Prop Master: Dean Karr (A Band Apart)
Henry Artist: Chris Staves (now of 'Method' formerly of 525 Post)
Telecine Operator/Colorist: Arnold Ramm (525 Post)
Agency Producers: Bob Gondell, Rob Thomas (Foote, Cone & Belding)
Agency Art Director: Antonio Navas (now of 'Amster Yard' formerly of Foote, Cone & Belding)
Agency Creatives: Corey Stolberg, Paul Wolfe (Foote, Cone & Belding)
Storyboard Artist: Chad McCown (Famous Frames)

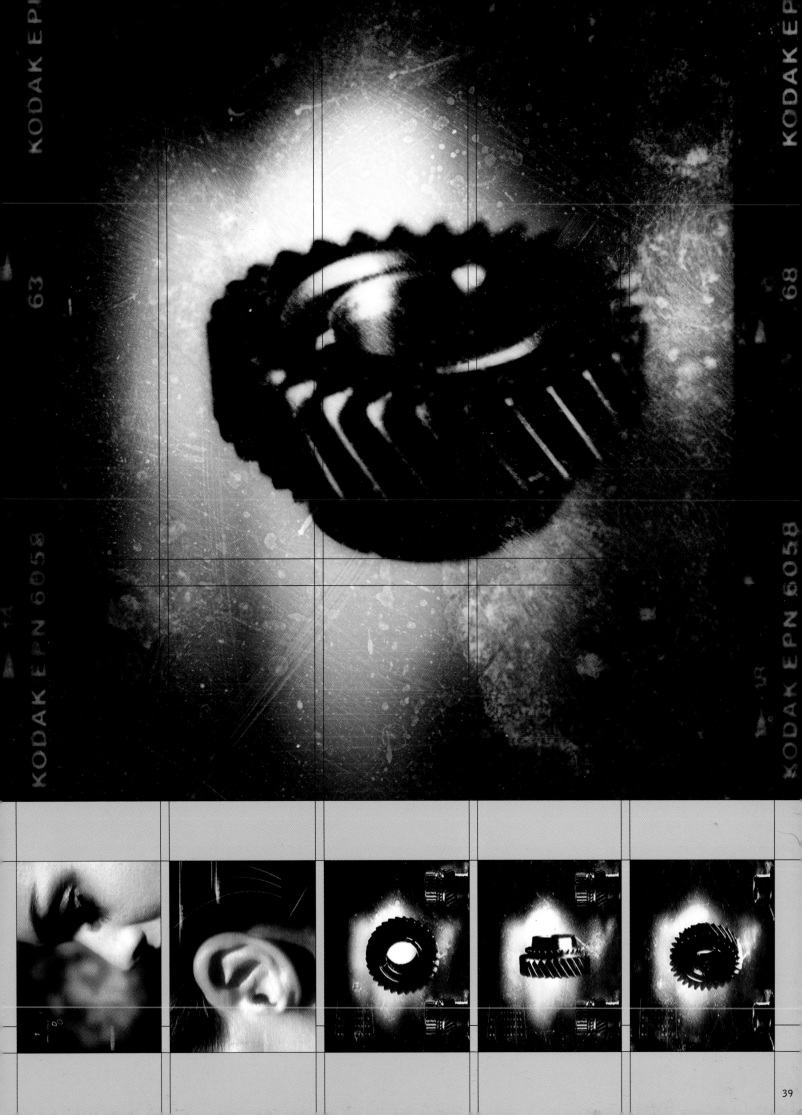

'We were simply trying to sell a car using sensual and mysterious imaging.'

Left: one of several hundred
20 x 24" contact sheets
created for the animatics.

DEVELOPMENT

Karr was given much creative freedom with the 'How it Measures' spot. No one was really quite sure what to expect as an end product, what they were certain of is that they had beautiful film footage, great photo animation and advanced graphics.

After Karr's initial meeting with the agency in San Francisco, the creative directors and producers traveled down to Los Angeles to work more closely with him. Karr did a series of very abstract storyboards to give them some kind of idea of the direction he wanted to take. Karr prefers to work without 'boards' or specific shot lists, the magic for him happens at the moment of conception. For example, the iron grid which frames the woman was simply an object that was hanging around the set and had no purpose until he placed it in front of the model's face. 'I love it when shots happen that way,' says Karr.

TECHNIQUE / KIT (Dean Karr)

Many techniques were used to arrive at the finished product. In the shooting stages Karr had ideas of which shots would incorporate technical information and moving data, so he purposely composed shots with areas of black negative space for Erik Bertellotti to install his scrolling information and line art. Bits of "photo animation" run through the spot, which are sequences of actual photographs shot with a Nikon F3 and motor drive. The photos were printed through a textured laminate, transferring the organic and chemical looking appearance onto the print. The series of "treated" photos are then reshot on an animation stand and recolored in the Telecine process. The finished result of this animation process takes on the appearance of an old-fashioned flip book of sequential images.

TECHNIQUE / KIT (Erik Bertellotti – Motion Graphics)

Graphics were created on a PowerMac with the following software: Adobe Illustrator, Adobe Photoshop, Adobe AfterEffects, and composited with Quantel Henry. The motion graphics designer was provided with an off-line edited version of the spot. This video, digitized from the film, was then loaded into the Mac. Graphics were designed to complement and interact with the photographic compositions. Some graphic elements incorporate fine details from actual product blueprints, others include digitized clips from the shoot as overlays to the main composition. Graphics respond and interact with picture and sound. The music and the action of the characters drive the motion of the animation. All graphics were designed to look organic – no pure white was used. Each graphic was degraded, then subjected to erosion mattes for mottling and shading. Additionally, a natural glow was added. The resulting graphics appear to be made of fluid light, emanating from and responding to photographic elements of the composition. It was vital that the graphics did not appear as an additional digital layer superimposed on top of the picture. The overarching design philosophy was to create "biomechanical" graphic elements that continually evolve, responding to and complementing the life and motion within the photography.

Erik Bertellotti can be reached at Perhapsatron +1 323 667 3045

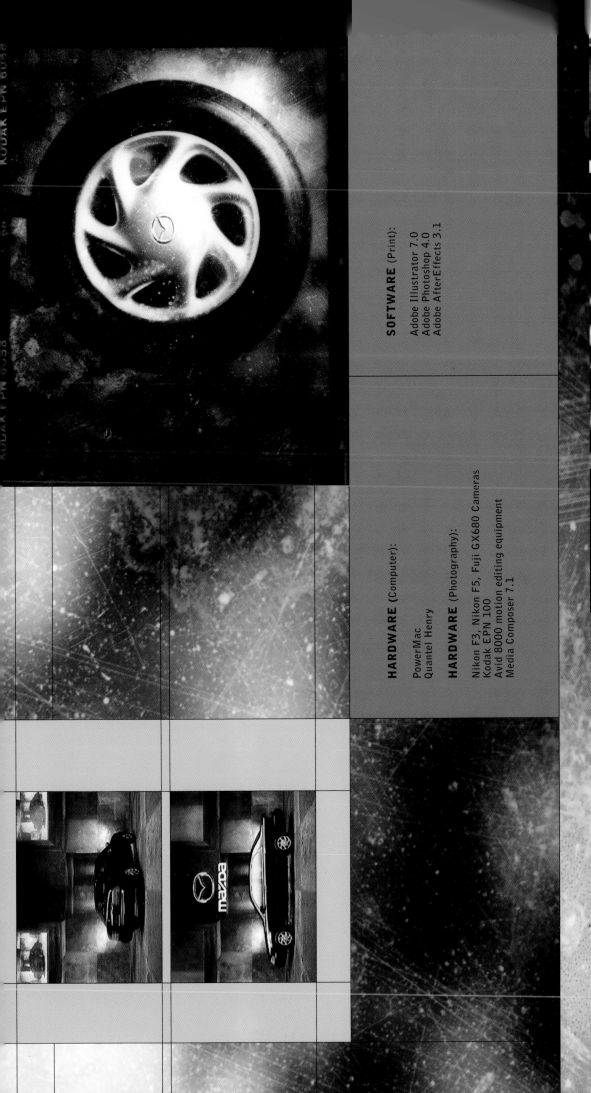

SOFTWARE (Print):

Adobe Illustrator 7.0
Adobe Photoshop 4.0
Adobe AfterEffects 3.1

HARDWARE (Computer):

PowerMac
Quantel Henry

HARDWARE (Photography):

Nikon F3, Nikon F5, Fuji GX680 Cameras
Kodak EPN 100
Avid 8000 motion editing equipment
Media Composer 7.1

Dean Karr
P.O. Box 691335
West Hollywood, California 90069, USA

Telephone: +1 310 917 3686
Contact: Yamani Watkins
E-mail: granfinger@aol.com
Website: www.mkgallery.com

SEE PAGE 146

Client List:
Capitol Records, EMI, Roadrunner Records, RCA,
Columbia, Virgin Records, Epic Records, Electra,
Nothing Interscope, Def Jam Recordings, Sony.

MARKUS KLINKO, photographer, began his adult life as a classical musician. At 15 he entered the Paris National Conservatory to study the classical concert harp, then had an illustrious career as an international harp soloist and recording artist for EMI Classics. Represented by Columbia Artists Management, Klinko performed throughout North America, Europe and Asia receiving great critical acclaim and was featured in such publications as 'Vanity Fair', 'Vogue', 'Harper's Bazaar', and 'The New York Times'. In 1994, after winning the Grand Prix de Disque for his last recording with the Paris Opera Bastille Orchestra, Klinko decided to turn his focus to the visual realm, as a fashion photographer.

INDRANI PAL-CHAUDHURI, digital artist and creative director, grew up in India and Canada, then entered the fashion business as a model at the age of 14. She studied photography and philosophy whilst working around the world, and is currently a student of Anthropology at Princeton University.

Together, Markus and Indrani experimented with various techniques, and quickly developed a photographic style involving elaborate lighting and digital technology. They are now based in New York and work closely with their hand-picked team of top digital artists, Mandi Riggi, Ginger, and Rebecca Arnold. Their work is seen regularly in such magazines as 'Interview', 'Vibe', Isabella Blow's Sunday Times 'Style', and British 'GQ'.

RESTRA ? ARATUS
STOCK OLM 1
WM. W. SM? CO.

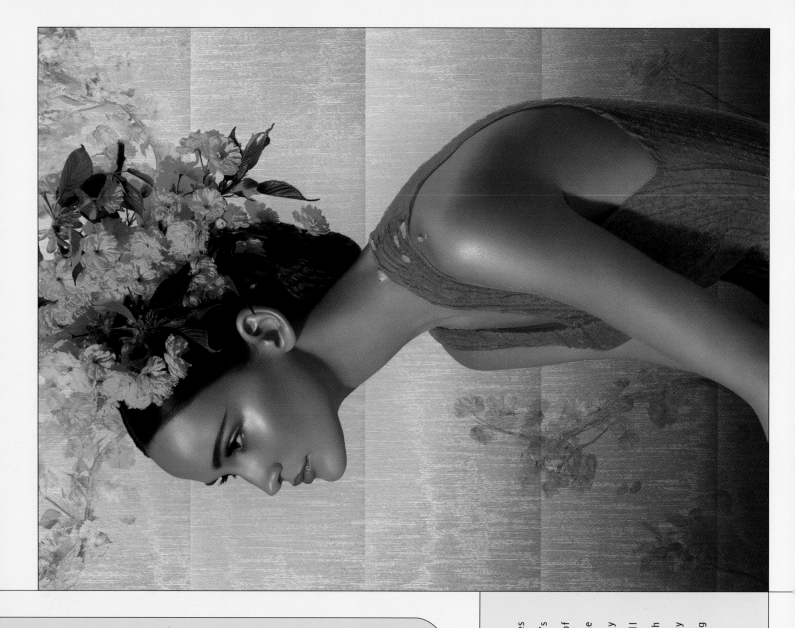

BACKGROUND

Markus Klinko and Indrani Pal-Chaudhuri met in 1994 and have worked together ever since. Although they share in the creative directions of their photographic projects their roles are also clearly defined, Klinko is the photographer while Pal-Chaudhuri oversees the digital manipulation. This marriage of the two media, for the most part, came out of the frustration of having to rely on other people to retouch their photographs.

They now have a completely self-sufficient studio which includes a comprehensive collection of photographic equipment as well as a drum-scanner, Silicon Graphics work station and several PowerMac G3 computers.

Their basic philosophy towards their work is trying to convey reality and fantasy on a common ground. Any tools that allow for this are valid, from building sets and using very complex lighting to using the computer in post-production. One of the first steps they take when shooting is to try and determine a way to make the lighting as dimensional or sculpted as possible. They are not too concerned with images that portray a realistic setting, even when shooting outdoors they will use artificial lighting along with the natural light source.

'To achieve our smooth skin textures we don't just clone (using Photoshop's stamp tool) the surrounding area of an imbalance or imperfection in the skin. Instead, working on a hugely enlarged screen view, we will meticulously paint over each imperfection with the brush tool by darkening the highlights or lightening the shadows.'

PROJECT ONE

Front Cover for **International Harper's Bazaar** (above)

Originally the model's shoulders were not considered "fragile" enough for the expression Klinko and Pal-Chaudhuri wanted to portray in the image. Through a very complex manipulation, Pal-Chaudhuri created the fragility they wanted by warping and stretching the model's upper torso with the program Eclipse (running on Silicon Graphics). Although the model's neck may appear to have been elongated it is her natural length.

The model was photographed in front of a gray background but all the lighting effects are as they appeared in the original photograph, for example, the red glow on her shoulders. Klinko feels he photographs his subject in the same manner as a 'still life photographer' and it is not uncommon for him to use up to 15 different light sources in a single image.

The background was composed of many different layers, again, Eclipse was mainly used for the basic composition but Photoshop was used for the complex layering. The silk texture is from a couch in the studio that Klinko photographed. After the flowers were removed from the model's hair they were photographed separately then digitally layered into the silk pattern. The shape of the flowers was also manipulated to follow the outline of the model's figure.

Almost a month was spent on this image experimenting with different digital techniques and compositions. Klinko and Pal-Chaudhuri consider this a milestone image for them because it opened up a door to a number of possibilities in how they would approach their work in the future.

PROJECT TWO

Editorial work for **Mirabella** magazine (left)

When they were scouting locations in Death Valley, Pal-Chaudhuri noticed a cloud of dust coming from a car as it drove down the road. They recreated this in the shoot to give the impression of an "other-worldly" mist coming up from behind the model.

Because Klinko had to shoot directly into the sun, he was only able to see a black silhouette of the model. A relatively slow exposure with strong flash lighting had to be used to capture the figure. 'It is like shooting blind, because you don't have anything to focus on,' says Klinko.

This photograph had a minimal amount of computer manipulation applied to it. The model was stretched, the skin was retouched and a few imperfections in the clothing were taken care of.

PROJECT THREE

Personal work (left)

This photograph was shot at sunset on the roof of Klinko's apartment building in New Jersey. Like the techniques used for the 'Death Valley' image on the previous page, Klinko had to use very strong frontal flash lighting as well as a slow exposure to capture the model.

The composition of this photograph remains the same as the original, but (as with most of their work) the skin has been extensively retouched. 'The type of lighting we use almost demands retouching later,' says Klinko.

PROJECT FOUR

Personal work (below)

This image was composed of four or five different shots. Because of the camera lens' limited depth of field when shooting extremely close, Klinko had to shoot several different photographs focusing on different parts of the lips for each shot. Pal-Chaudhuri later "spliced" them together on the computer and removed the tiny hairs around the mouth.

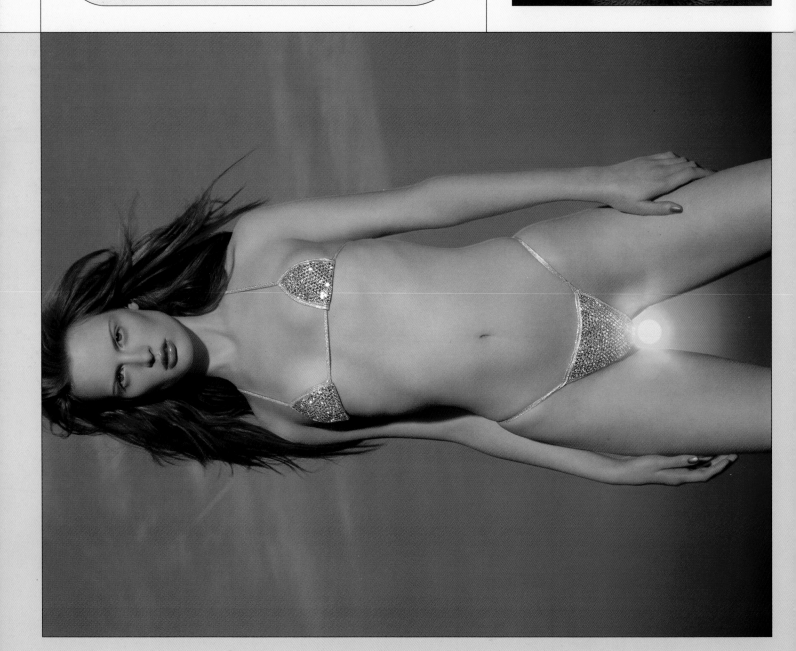

'No matter what tools are used to create something that is extremely polished or impeccable it will eventually lead to an impression of illustration.'

Editorial double page spread for 'Stern' magazine (Germany)

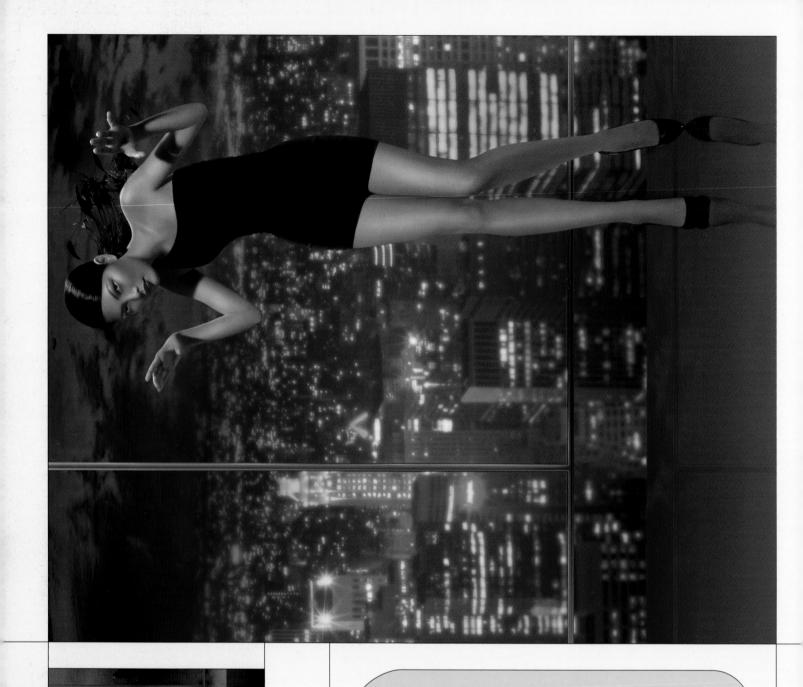

PROJECT FIVE

Personal work (this page)

Without looking "futuristic", Klinko and Pal-Chaudhuri wanted to do a series of photographs portraying a time set in the near future while maintaining an appearance of reserved luxury. The idea was to have the same room but each of the images would reflect the different personalities of the models.

The skyline was shot from a high rise in New York. Some of the night photographs required up to a three minute exposure which proved to be difficult. For safety reasons, the building they were shooting from would not allow the use of an open tripod so Klinko had to steady it between his legs while his assistants made sure that no tourists would bump into him.

The models were shot in the studio and were then combined with the skyline as well as stretched and tweaked in post-production. Pal-Chaudhuri spends an incredible amount of hours precisely cutting out the figures from their original backgrounds and the same amount of attention to detail is spent on making sure the edges of the cut out figures blend seamlessly with their new surroundings.

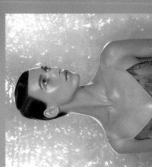
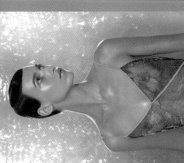
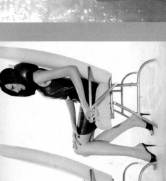
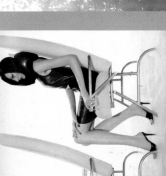
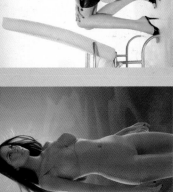

When the 'Skyscraper' series was first produced, a number of art directors and magazine editors had reservations about the work but now they are asking for images to be created in a similar style. For instance, after seeing the 'Modern China Doll' image (above), British 'GQ' asked Klinko and Pal-Chaudhuri to replicate that shot for an editorial feature on the British teen pop singer Billie (left). The editors from 'Vibe' magazine have also asked them to do something similar for them featuring another personality.

'Our work is pretty much a product of a post-production point of view.

Indrani, my partner, has very different ideas than I have and that

is what is so challenging. This is what also makes it such a great

experience, we approach a project from two separate points of view

and in the end create something that we both really love.'

HARDWARE (Computer):

PowerMac G3
Silicon Graphics Octane Platform

HARDWARE (Photography):

Mayima Camera (6x7cm format)
Velvia film

SOFTWARE (Computer):

Eclipse
Adobe Photoshop 5.5

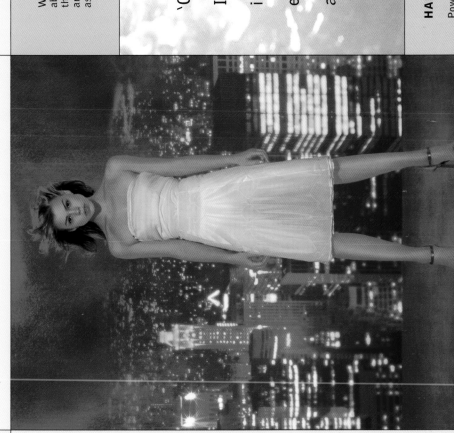

Markus Klinko and Indrani Pal-Chaudhuri

Representation: Mutale Kanyanta, Art Department, 4th Floor
48 Green Street, New York City, New York 10013, USA

Telephone: +1 212 925 4222
Fax: +1 212 925 4422
E-mail: markusk@earthlink.net
Website: www.klinko.com

SEE PAGE 147

Client List:
'Interview' (USA), 'Vibe' (USA), 'People' (USA), 'GQ' (UK), 'Arena Homme Plus' (UK), Isabella Blow's Sunday Times 'Style' (UK), 'French Max', 'Stern' (Germany), Electra Records.

KM7 : visual translator of da' bass and da' beat.

'Design is a marriage of type and image. Color, space and dimension become graphics. Sound and words make music. Type is a tool and lines are just weapons in the fight for optical pleasure. If you can't hear it but you can see it, then you've already felt it. Graphic design should bring forth emotion through visualization. Design should never be the same: what you see is what you hear.'

THE PROJECT

Tripomatic Fairytales 2001 and **Tripomatic Fairytales 2002** album sleeve designs for producers, Jam & Spoon, plus several single sleeves, adverts, posters and flyers

BACKGROUND / BRIEF

The two producers Jam & Spoon and Klaus Mai had known each other from clubbing. Jam & Spoon had seen some of the flyers Mai had done for various clubs and asked him to do the artwork for their project. Mai's work has always been heavily influenced by electronic music and he gladly accepted the challenge. That was in 1993 and Mai has worked with them ever since, the most recent project being the 1999 single sleeve for 'Stella'.

Project Credits:

Design and concept: Klaus Mai
Photographer: Marc Trautmann
Lyrics: Christine Pfaff

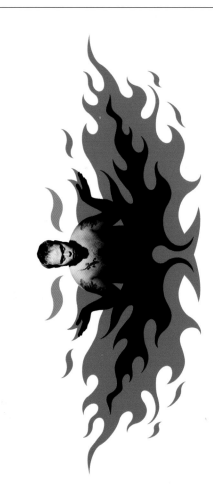

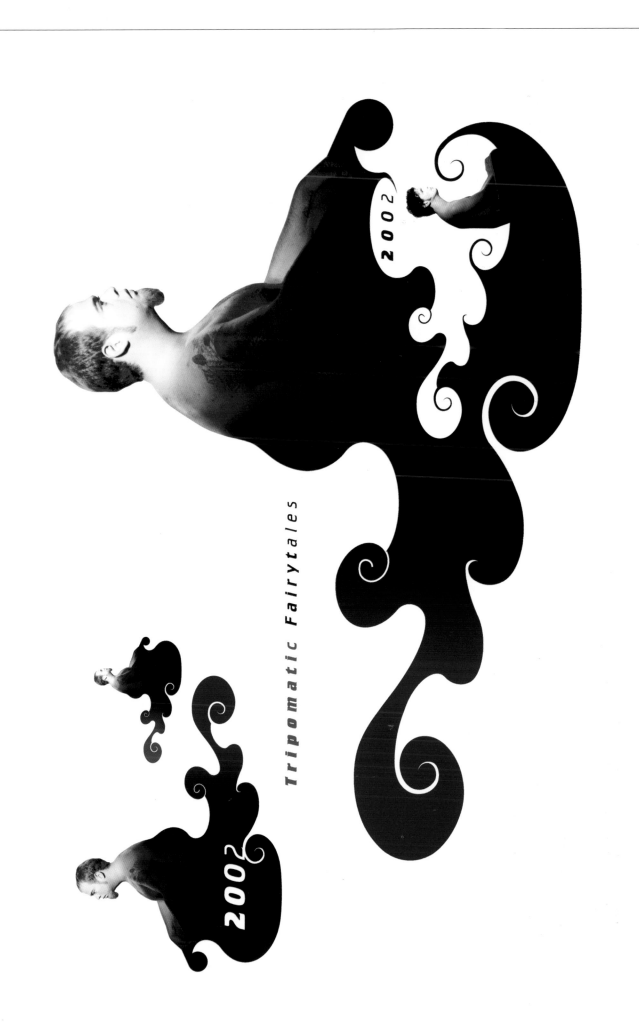

Tripomatic Fairytales

2002

2002

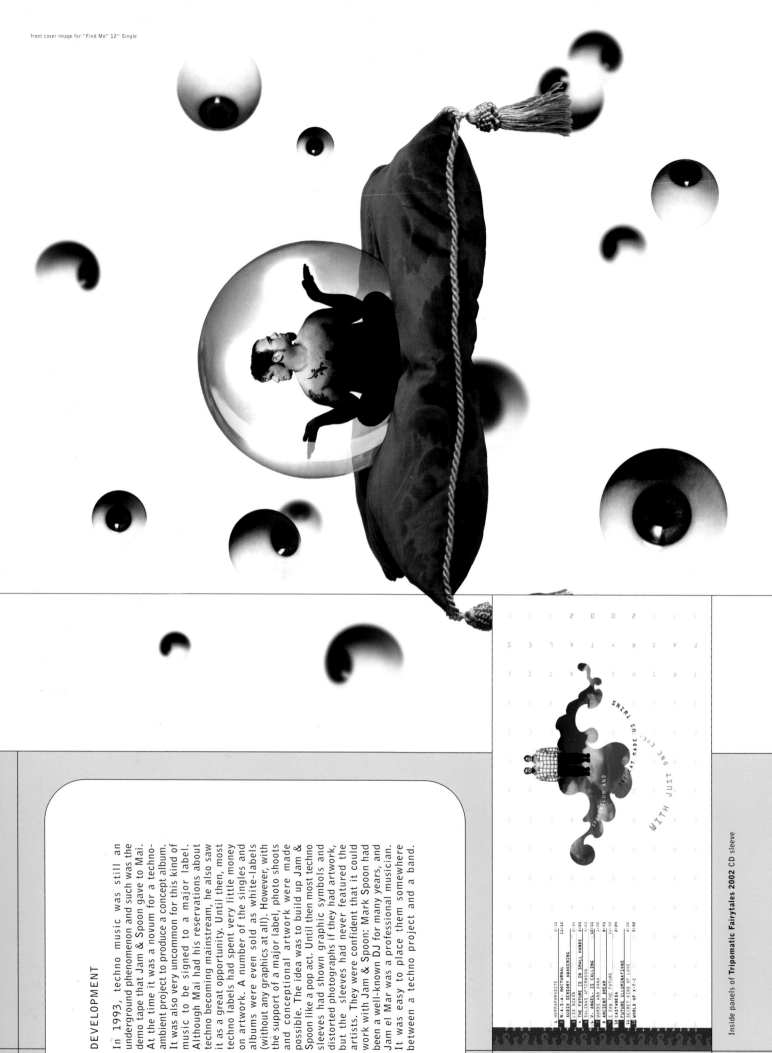

front cover image for "Find Me" 12" Single

DEVELOPMENT

In 1993, techno music was still an underground phenomenon and such was the demo tape that Jam & Spoon gave to Mai. At the time it was a novum for a techno-ambient project to produce a concept album. It was also very uncommon for this kind of music to be signed to a major label. Although Mai had his reservations about techno becoming mainstream, he also saw it as a great opportunity. Until then, money techno labels had spent very little money on artwork. A number of the singles and albums were even sold as white-labels (without any graphics at all). However, with the support of a major label, photo shoots and conceptional artwork were made possible. The idea was to build up Jam & Spoon like a pop act. Until then most techno sleeves had shown graphic symbols and distorted photographs if they had artwork, but the sleeves had never featured the artists. They were confident that it could work with Jam & Spoon: Mark Spoon had been a well-known DJ for many years, and Jam el Mar was a professional musician. It was easy to place them somewhere between a techno project and a band.

Inside panels of **Tripomatic Fairytales 2002** CD sleeve

'We liked the idea of Jam & Spoon appearing as characters from 'Alice in Wonderland'.'

All of the artwork for both albums is based on Lewis Carroll's 'Alice in Wonderland'. It was the parallel of fairytale and drug experiences that interested Mai and he applied this motif to many playful elements of the booklet. For example, Mark Spoon is the pipe-smoking caterpillar on the mushroom. And the invented name 'Spoonilum & Jamdidei' clearly refers to Humpty Dumpty.

They used the Janus head with its strong graphic elements on both of the front covers for a number of reasons, but most importantly because it introduced the producers Jam & Spoon as real people (as a band) and it had the dual function of acting as a logo.

'Tripomatic Fairytales 2001' is more of a techno dance album so they chose the more powerful motif of flames, whereas 'Tripomatic Fairytales 2002' is more of an ambient album, so they chose a much subtler background.

Front cover image for **Tripomatic Fairytales 2002**

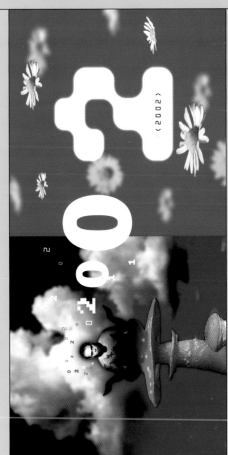

Images from inside panels of **Tripomatic Fairytales 2002** CD sleeve

Small "poems" were also created to be used as additional graphic elements; like 'The cat made us twins with just one eye', which was combined with a photograph of Jam & Spoon as Siamese twins. This relates to the main motif of the Janus head on the front cover. 'Best medicine that doctor gave to me, first I felt sick now I feel free' is another line that was used. There were many other "poems", but they had to be abandoned because the record company thought they were too obviously drug-related. All the artwork was viewed by the band before presenting it to the record label. The label was happy with everything that was presented and did not change anything except of course the "poems" they felt uncomfortable about.

TECHNIQUE / KIT

The photographs were shot using E6 film, and then developed as negative film (i.e. cross-processing): the scans were then taken from the prints. Later, this process turned out to be inappropriate for the whole project, but at that time they cross-processed everything.

All the original motifs were sketched out as thumbnails before transforming them into FreeHand 3.0 and Photoshop 3.0 computer-based artwork. For the Janus head, the flame motif was drafted on paper, then scanned into the computer to be used as a template in FreeHand so it could be made into a vector graphic. It was then exported into Photoshop and combined with the band photographs to create the desired effect. 'All visual ideas were developed on paper, not on the monitor,' explains Mai.

Front cover of 'Angel' 12" single sleeve

Original photographs for **Tripomatic Fairytales 2002**

Original thumbnail sketches for **Tripomatic Fairytales 2002**

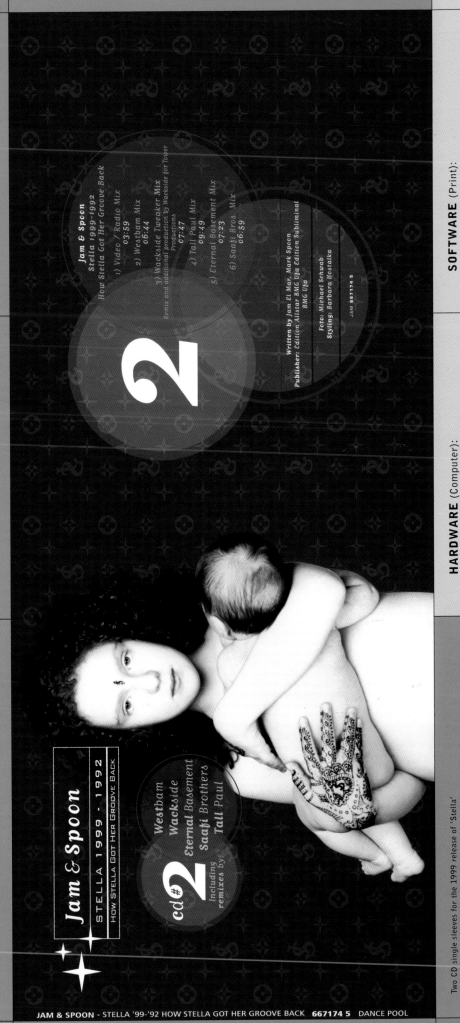

Jam & Spoon
STELLA 1999 - 1992
HOW STELLA GOT HER GROOVE BACK

cd #**2**
Westbam
Wackside
Eternal Basement
Saafi Brothers
Tall Paul

Including remixes by:

JAM & SPOON - STELLA '99-'92 HOW STELLA GOT HER GROOVE BACK **667174 5** DANCE POOL

Jam & Spoon
Stella 1999-1992
How Stella Got Her Groove Back

1) Video / Radio Mix
03:59
2) Westbam Mix
06:44
3) Wackside Tweaker Mix
Remix and additional production by Wackside for Tower Productions
07:47
4) Tall Paul Mix
09:49
5) Eternal Basement Mix
07:23
6) Saafi Bros. Mix
06:59

Written by Jam El Mar, Mark Spoon
Publisher: Edition Allstar BMG Ufa Edition Subliminal BMG Ufa

Foto: Michael Schwab
Styling: Barbara Hostalka

JAM 667174 5

Two CD single sleeves for the 1999 release of 'Stella'

SOFTWARE (Print):

Macromedia FreeHand 3.0, 8.1
Adobe Photoshop 3.0, 5.0

HARDWARE (Computer):

PowerMac G3 – 450 Mhz
Macintosh 9500 – 200 Mhz

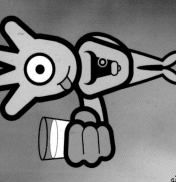

Designbureau KM7
Schifferstrasse 22
D-60594 Frankfurt
Germany

Telephone: +49 69 96 21 81 / 30
Fax: +49 69 96 21 81 / 22
E-mail: Klaus.Mai@frankfurt.netsurf.de
Website: www.km7.de

SEE PAGE 148

Client List:
Audi, Swatch, Volkswagen, Universal Music, Sony Music, Nike.

59

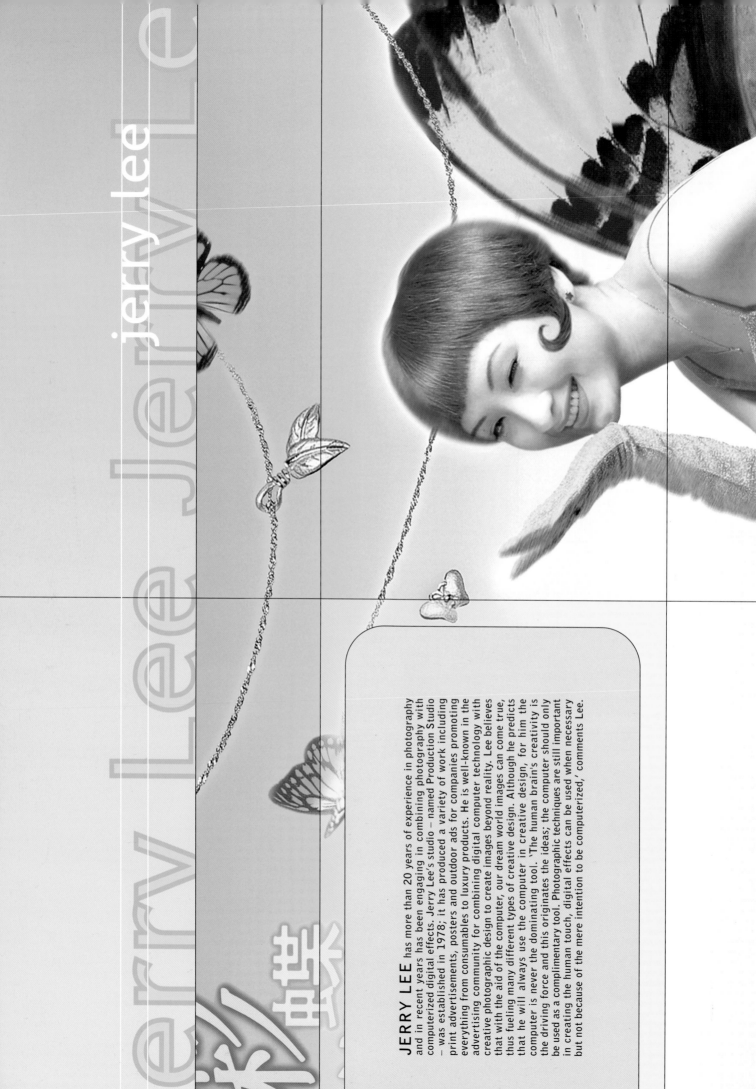

JERRY LEE has more than 20 years of experience in photography and in recent years has been engaging in combining photography with computerized digital effects. Jerry Lee's studio – named Production Studio – was established in 1978; it has produced a variety of work including print advertisements, posters and outdoor ads for companies promoting everything from consumables to luxury products. He is well-known in the advertising community for combining digital computer technology with creative photographic design to create images beyond reality. Lee believes that with the aid of the computer, our dream world images can come true, thus fueling many different types of creative design. Although he predicts that he will always use the computer in creative design, for him the computer is never the dominating tool. 'The human brain's creativity is the driving force and this originates the ideas; the computer should only be used as a complimentary tool. Photographic techniques are still important in creating the human touch, digital effects can be used when necessary but not because of the mere intention to be computerized,' comments Lee.

PROJECT ONE

Lucozade Christmas Promotion
In-store Display Poster

BACKGROUND / BRIEF

Lucozade, a distributor of various health drinks, was introduced to Jerry Lee through referral. The target market of Lucozade is health-conscious and sport-minded customers, with an emphasis on youth. In 1998, a number of competitive health drinks appeared in the retail market and the client wanted to strengthen their brand image and presence in that market. As the launch date of the poster was during the Christmas season, this festive concept was applied to the campaign.

DEVELOPMENT

Lucozade is considered a drink which can revitalize your energy, especially after physical activities like sports. A pair of battery cables with clamps were used to convey this message. To further enhance the "charged" energy, the Christmas decorations were given the appearance of being electrified. Because of the competitive time of the year in the retail market, it was decided that vivid colors should be used with the hope that it would easily catch the attention of customers. Digital technology played an important role in conveying the "electrifying" effect of the product and conveying the brand's message, 'A Drink to Charge You'.

Project Credits:

Photographer: Jerry Lee
Creative Director: Jerry Lee
Retoucher: Jerry Lee

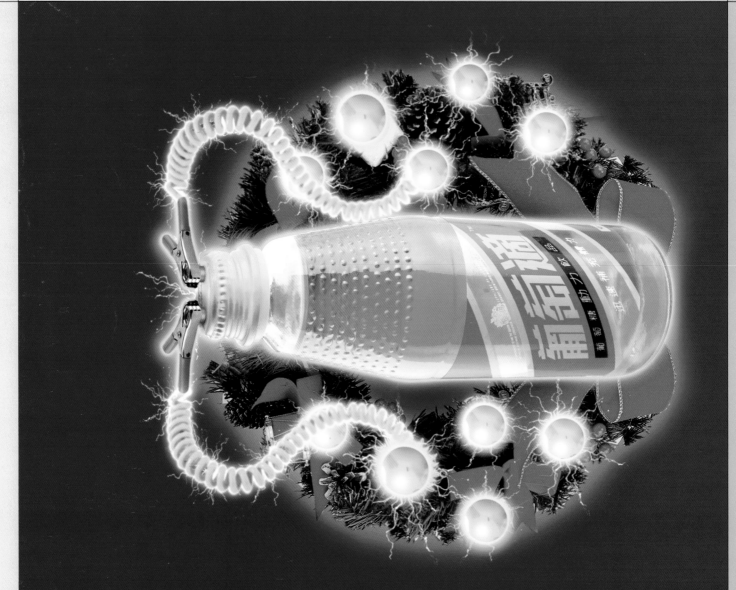

The finished poster

62

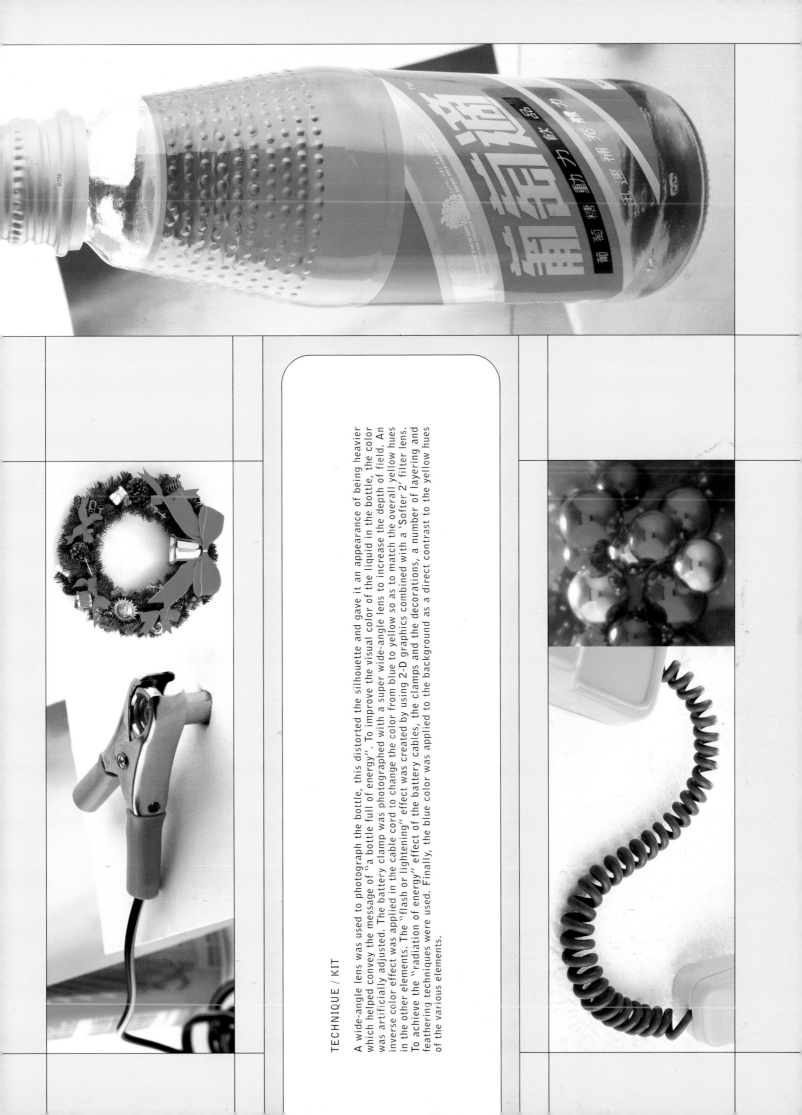

TECHNIQUE / KIT

A wide-angle lens was used to photograph the bottle, this distorted the silhouette and gave it an appearance of being heavier which helped convey the message of "a bottle full of energy". To improve the visual color of the liquid in the bottle, the color was artificially adjusted. The battery clamp was photographed with a super wide-angle lens to increase the depth of field. An inverse color effect was applied in the cable cord to change the color from blue to yellow so as to match the overall yellow hues in the other elements. The "flash or lightening" effect was created by using 2-D graphics combined with a 'Softer 2' filter lens. To achieve the "radiation of energy" effect of the battery cables, the clamps and the decorations, a number of layering and feathering techniques were used. Finally, the blue color was applied to the background as a direct contrast to the yellow hues of the various elements.

Various elements which went into the poster (the model is shown after computer manipulation of hair and glove colors)

PROJECT TWO

Jewelry Promotion Poster
Spring Collection – The Legend of the Butterfly

BACKGROUND / BRIEF

The client, a jewelry manufacturer and retailer, selected Jerry Lee after reviewing several other candidates for the project. The target customers for the launch of their spring collection of gold jewelry were young women (16–25 years old) who were looking for cute and fresh jewelry. The client wanted a look which would convey their brand image as young and lively, while fulfilling the dreams of the young customers in a fairytale setting. Lee and the creative director, Benny Lui, worked closely with the client in all areas of the creative process.

Project Credits:

Photographer: Jerry Lee
Creative Director: Benny Lui
Retoucher: Jerry Lee

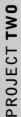

'The client was looking for an image which would fulfill the fairytale dreams of its young customers.'

DEVELOPMENT

The model with the aid of computer manipulation became the "butterfly fairy", announcing the coming of spring as the gold jewelry comes to life with her gentle blow. The butterflies were added to create a sense of unlimited space and through the use of pastel pink, a dream or fairytale effect was created. Lee added a glow around the jewelry to further enhance the idea of the jewelry coming to life. To create the finished image, a real sunflower and samples of butterflies were used. The initial concept was introduced to the client as sketches and during the meeting the ideas were finalized and samples chosen for the poster. Digital technology played an important role in combining the different elements (model, flower, butterflies and gold jewelry) and blending them to create a soft mood, while at the same time maintaining a focus on the client's jewelry.

TECHNIQUE

A digital camera was used to achieve more vivid and three-dimensional images, especially for the photography of the gold jewelry. Images of the model and the sunflower were photographed using a traditional camera then drum-scanned, giving the model a softer complexion and the flower a fresh, lively look. Digital retouching was essential in creating the "fairytale" mood and highlighting the gold jewelry. Color adjustment together with scaling and layering were applied in Photoshop. For the headline, Illustrator was used. The final image was output as an RGB film transparency using the Fire Drum 800. All digital work was done on a Silicon Graphics workstation and the Macintosh.

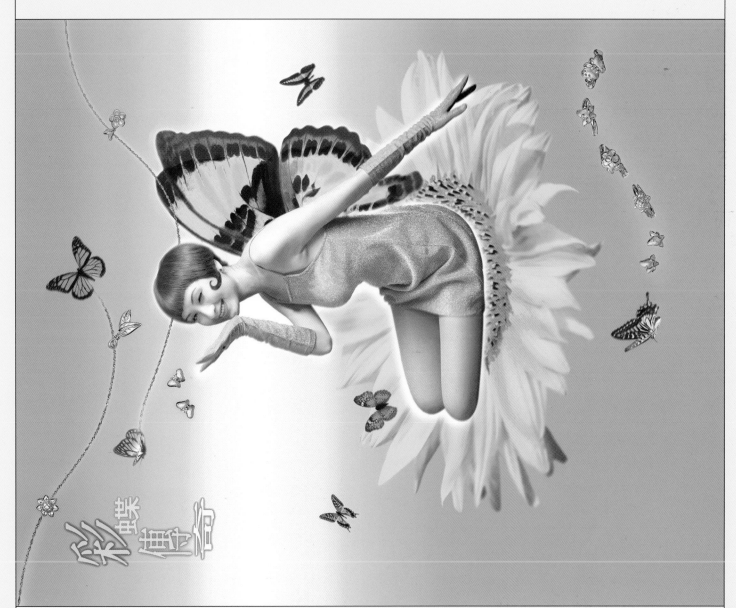

The finished poster

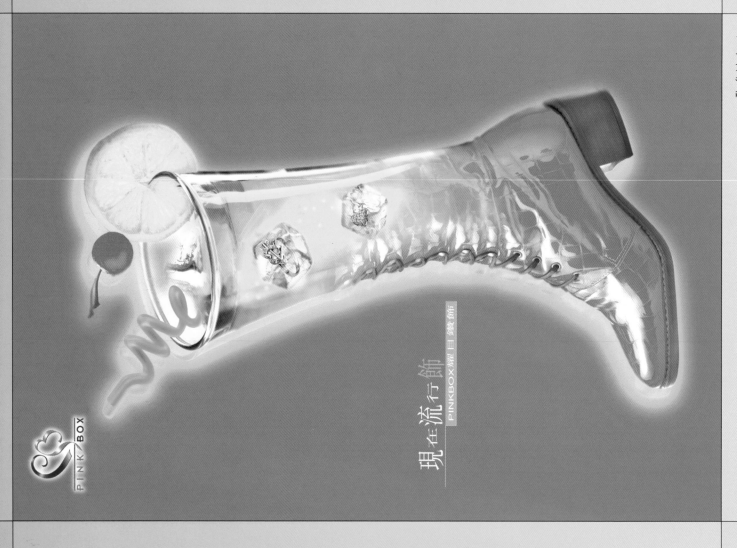

PINKBOX

現在流行飾
PINKBOX耀目鑽飾

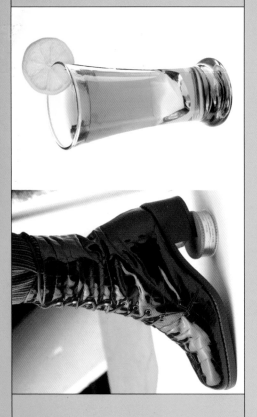

PROJECT THREE

Jewelry Promotion Poster
Summer Collection

BACKGROUND / BRIEF

This poster was one of three which promoted different jewelry categories: '24 carat gold', 'pearls' and 'diamonds'. The objective was to strengthen the brand image of the client's jewelry (considered youthful and lively) and to promote their summer collection.

DEVELOPMENT

To arouse the interest of the customers, the concept of combining two completely different objects was applied to this ad campaign. A cocktail combined with a boot was chosen to create a sense of summer. The boot was used to project a feminine and trendy image, while the cool cocktail drink and the ice cubes containing diamond jewelry highlighted the sparkling clarity of the diamonds while suggesting summer (For the other two ads, '24 carat gold' used the combined image of a racket and Bonbon candy and 'pearls' used the combined image of a cosmetic case and a CD player). Lee and the creative director, Benny Lui, worked closely with the client in selecting the props and jewelry and perfecting the layout. This poster, together with the other two in the campaign were well received by the public and Lee received a number of inquiries after they were published.

TECHNIQUE / KIT

To photograph the many different objects in this project it was important to keep their various material qualities, perspectives and lighting in mind. For example, the boot was photographed at a mid-level angle while the glass was shot at a high angle to balance their combined perspectives. Hard backlighting was used when photographing the glass to achieve a cool, refreshing quality. For other accessories such as the lemon, hard backlighting was also necessary to create the fresh transparent appearance.

With the use of various computer retouching techniques the summer mood and translucent look was achieved. By exaggerating the brightness of the diamond jewelry it was easier to blend the ice cubes with the jewelry. With the addition of bubbles in the cocktail drink, the feeling of "coolness" was also heightened. As the boot was originally very solid in appearance, color adjustment with the use of the hue/saturation filter in Photoshop was applied to achieve the transparency required. Finally, the feather filter was applied to create the "cool" glow of the image.

Project Credits:

Photographer: Jerry Lee
Creative Director: Benny Lui
Retouchers: Jerry Lee, Tommy Wan

HARDWARE (Computer):

Silicon Graphics
PowerMac G3
Alfa 4x5" Film Recorder
Fire 800 8x10" Film Recorder
Screen Drum Laser Scanner
3M Rainbow color proofing

HARDWARE (Photography):

Digital Cameras:
Sinar DCS 465
Color Crisp Carnival 2020

Traditional Cameras:
Sinar 8x10"
Sinar 4x5"
Hasselblad
Nikon
Hensel 8x10" Front Protection
Hensel Light Painter

Film Type:
Kodak EPP 6105
Fuji RDPII

SOFTWARE (Computer):

Eclipse
Adobe Photoshop
Adobe Illustrator

Jerry Lee
Production Studio
Flat A, 9/F, Po Ming Building, 2 Foo Ming Street
Causeway Bay, Hong Kong

Telephone: +852 2890 8773 or +852 2895 1536
Fax: +852 2576 1085
E-mail: jerry2c@hkstar.com or jerry@hkipp.org

SEE PAGE 149

Client List:
Grand Hyatt Hotel, Johnson & Johnson (HK), Pizza Hut, Motorola, Standard Chartered Bank, Chase Bank, 3M (HK), Fuji Photo Products, Mobil Oil (HK), Hong Kong Post Office.

catherine McIntyre

CATHERINE McINTYRE currently works as a computer-based illustrator, specializing in book editorial and cover work, magazine illustration and CD covers. Originally a total technophobe, she was fortunate enough to be forced into computer graphic design out of the necessity to pay the mortgage; a completely digital working environment soon taught her what it was – and just as importantly, what it wasn't – possible to create with the medium. A natural propensity for collage, for organizing elements within an image, for selection, and for setting up gestalts from unrelated recycled parts made Photoshop a godsend. Her initial belief that nothing emotional could happen without physical creation was completely overturned. The fact that these images were ideas trying to become visible suited perfectly a medium which allows creation somewhere between the two – between pure thought and the physical result. McIntyre writes, 'pictures in progress are in flux, evanescent and growing simultaneously, allowing an unusual amount of decision-making both forwards and backwards in time. It is an instinctive process, one which allows technical problems to recede in importance and the real business of communication to happen.

Artist's Statement

The work presented here is the latest in an ongoing personal project which has been developing for many years through a variety of media, along several major themes.

I began in the life studio, which teaches an understanding of form, light and dimension. An abiding fascination with anatomy, the mechanics and modes of the body, and measurement was born here. A Masters degree in photography began the exploration of a nude at once more, and less, literal than that of the drawing class. The images began to assert themselves, to become ends in themselves; they came to express very personal philosophies, obsessions, states of mind and emotions.

The layering techniques available in Photoshop were a revelation. Initial attempts at collage had always been restricted by the given scale and color of found objects and photographs, and by the physical problems of attachment; transluceny, too, was not available. In Photoshop, there are no such restrictions. Images can be compiled from widely differing sources and fine-tuned with unprecedented technical ease and subtlety into a coherent whole.

The nude is an important recurrence, a natural symbol of the laying bare of innermost feelings, and has been a continuing metaphor in my work. It can radiate wellbeing, or vulnerability and weakness; it can symbolize humanity's deepest essence, or that of the natural world; it can be idealized, realistic, grotesque, dismembered, impersonal, abstracted. The endless ways of representing the nude all carry with them resonances inevitably associated with the depiction of ourselves at our most unprotected. Images of the nude are impossible to ignore.

The pieces work, I hope, on two levels. On the aesthetic level of texture, color and pattern, the work is about finding correlations, echoes, and new resonances between disparate forms and surfaces, often between natural and manufactured objects in decay. The laws of physics act equally upon nature and the work of man; some pictures show nature asserting itself and reducing man's efforts to their original elements, while others have nature under threat from encroaching industrialization. This latter feeling of weight, crushing, compaction, pinning down and hemming in, isolation and ultimately of thread, became elements of the second, emotional level of the work.

The abstract of aging is also important in the textural elements of the work; the beautiful effects of weathering and distressing on often very unprepossessing substrates being at once destructive and creative carries a paradox mirrored in the aging of the individual.

Another theme is the difficulties of communication. Any conversation is a microcosm of the dissembling, misunderstanding and preference of everyday transactions. The space between implication and inference, into which so much of importance seems to disappear, the gap between the projected and the true self; the misapprehensions inevitable when thoughts are translated, more or less efficiently, or not at all, into words — all these are the subject of much of my latest work. The figure has become a symbol of veracity, lack of pretence, honesty — and vulnerability.

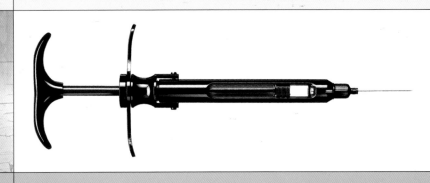

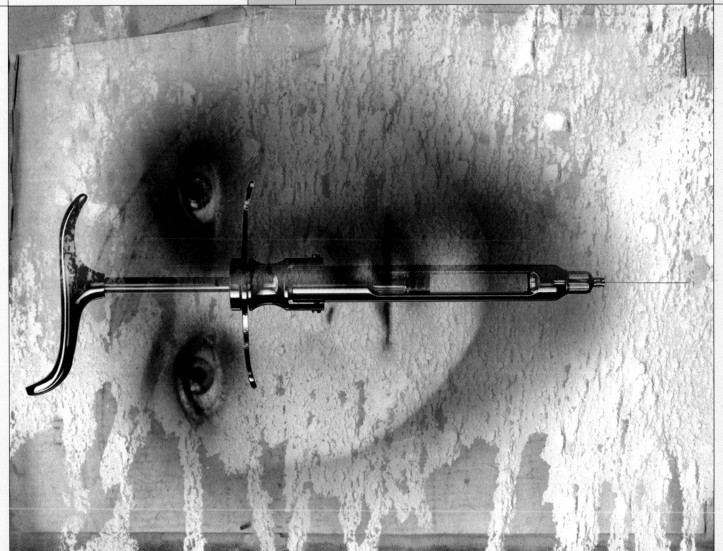

THE PROJECT

A Book Of Images
Publisher: Pohlmann Press (Los Angeles)

BACKGROUND

'To create a book of images which will communicate. The determinedly abstruse nature of much modern art seems to me to deny the very purpose of it. I wanted the pictures to inspire emotion, to encourage exploration of the content literally and psychically, to make inner landscapes visible. I wanted the pictures to work together and to strengthen each other.'

Project Credits:

Catherine McIntyre would like to thank Mr Sean Earnshaw at the University of St Andrews with whom she collaborated on many of the nude elements and whose still life work is also incorporated into a number of the pictures.

OPIATES

The basic elements

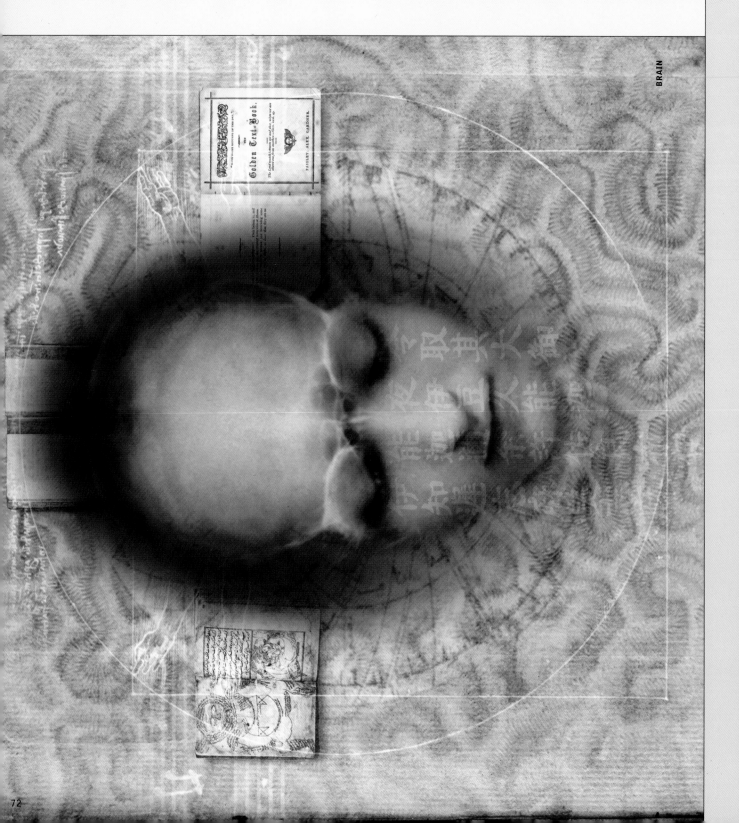

BRAIN

'I often try to create something new out of the old. There is a reality and a truth in using old, real objects which have been loved and worn and have decayed, and which therefore carry the marks of a life and tell a story; they give depth and veracity to computer art which can otherwise become too clean, surgical and unrelated to real experience. I feel the presence of the old within the new technology is vital to link the images to our past and so to our nature.'

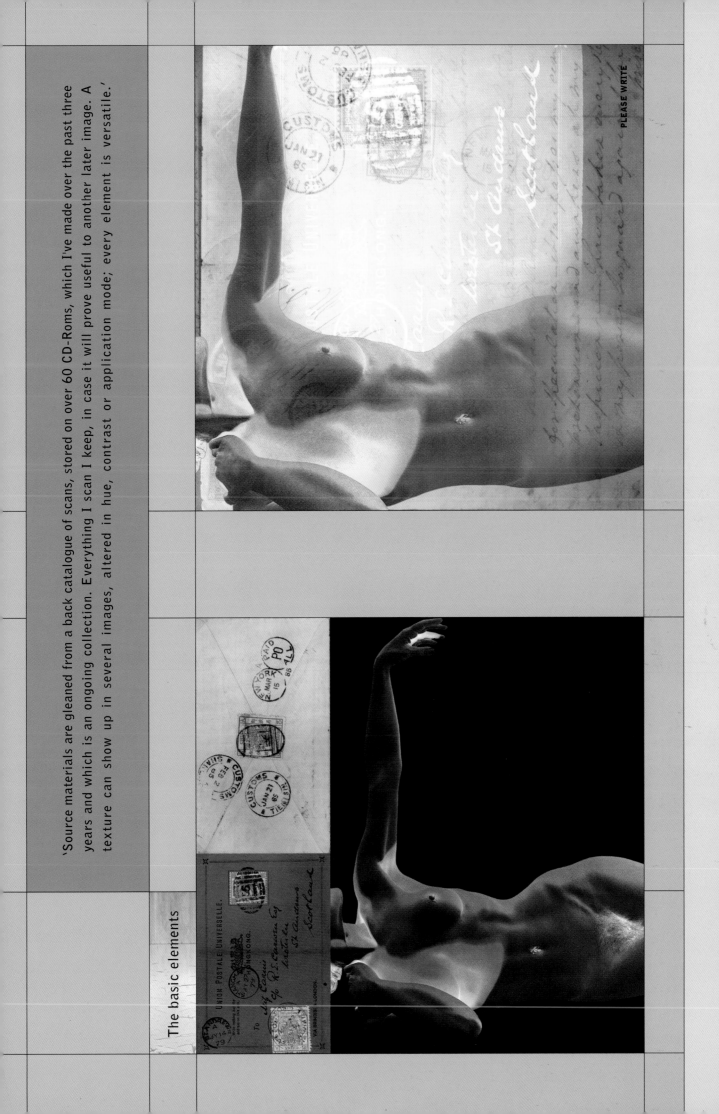

'Source materials are gleaned from a back catalogue of scans, stored on over 60 CD-Roms, which I've made over the past three years and which is an ongoing collection. Everything I scan I keep, in case it will prove useful to another later image. A texture can show up in several images, altered in hue, contrast or application mode; every element is versatile.'

The basic elements

'The endless ways of representing the nude all carry with them resonances inevitably associated with the depiction of ourselves at our most unprotected.'

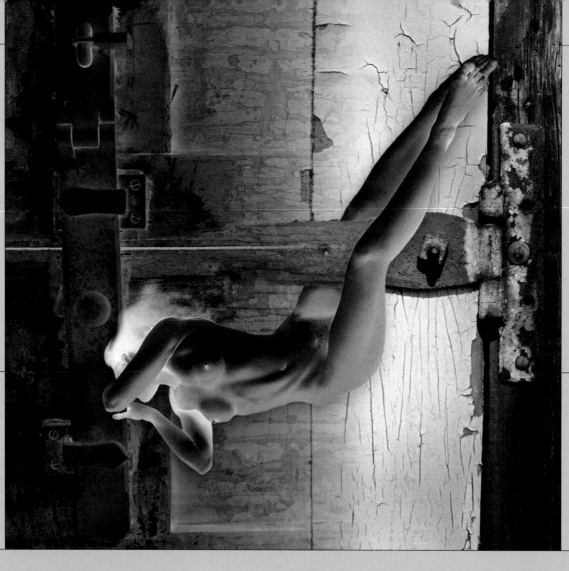

TECHNIQUE / KIT

All these images began life as a series of scans on a PowerMac 8600/250. Original material can be photographic negatives or positive film, drawings or collages, or things that McIntyre finds on her walks with the dogs – anything from a shred of wallpaper to an old crisp packet.

McIntyre photographs using a Nikon F401, with a macro-zoom lens for her various texture images. Because of the absence of familiar scale in abstract images, which are vital to the later work, textures take precedence over the subject matter. The nude elements are studio shots, made on a 6x6 format Bronica in collaboration with Sean Earnshaw of the University of St Andrews. McIntyre creates drawings of poses, decides the lighting set-ups, and then discusses the "feel" required for each shot with Sean. Since McIntyre is also the model, the technical difficulties of self-portraits are far too limiting to the pose, and a perceptive eye behind the lens ensures that each shot is how it was planned.

'Once in the computer, Photoshop 4.0 is the program that brings all the elements together. In my opinion it is the most versatile, subtle and precise photo-editing tool currently available. The standard collage techniques, used since Braque invented them, are all here. Any number of elements can be pasted into a picture, in layers one on top of another; the order in which they are placed can be changed at any time. The elements can be trimmed and rotated, just as with a paper montage. However, Photoshop goes much further. The scale of the various parts can be altered and they can be distorted, for example to create a perspective effect. Then, opacity can be varied, either across an entire layer or in parts using a layer mask. Contrast, hue, and saturation are further variables. Each layer can also interact with the ones below it by using layer modes. The luminosity mode, for example, makes the layer it is applied to take on the hue of the layer below, while retaining its own tonal and contrast values,' says McIntyre.

To create an image, McIntyre will start with an abstract texture, which she would use as a background on which to build. Then she will open the other files which she plans to use for the image, and copy and paste them into the working file in separate layers. At this early stage, the rough scaling and orientation of the elements is established.

Experimentation with inversions, changing colors, opacity and modes begins to establish the "feel" of the new picture. The mood is not something she plans – it develops just as with more traditional ways of making pictures, in a very intuitive and spontaneous way, reacting to the resonances set up by the interaction of the elements. Very often, the original elements of an image are rejected altogether as things more pertinent to the mood and shape of the piece are brought in. Once McIntyre is satisfied with the results, the layered Photoshop file is "flattened" to fix the parts together then output to a quality dye-sublimation printer.

'I don't usually have a final picture in mind when I begin something. Sometimes, a title comes first, an interesting word or idea which can arrive apparently out of nowhere and begin to suggest colors, symbols or connections – but these pictures aren't illustrations of a word; they seem to inform their own progress, and reveal things as they develop about their content – and about me, too...' McIntyre reveals.

The basic elements

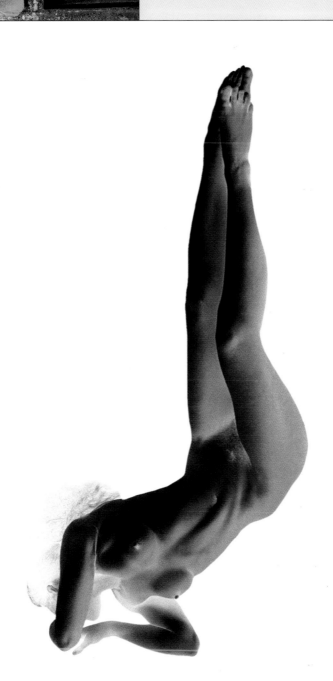

HARDWARE (Computer):

PowerMac 8600/250
UMAX Astra 1200S Flatbed Scanner
Nikon Coolscan
Epson Photo EX Printer

HARDWARE (Photography):

Nikon F401 (28–80mm Zoom Lens)

SOFTWARE (Computer):

Adobe Photoshop 4.0

Catherine McIntyre
8 Park Avenue
Dundee, DD4 6PW, Scotland, UK

Telephone: +44 1382 458 083
Fax: +44 1382 860 907
E-mail: c.mcintyre@cableinet.co.uk
Website: wkweb5.cableinet.co.uk/c.mcintyre/home.html

SEE PAGE 150

Client List:
Bridgewater Book Company, Godsfield Press, Focal Press,
RotoVision, Ivy Press, the University of Dundee and the University
of St Andrews, 'The Scotsman' (UK).

me company

ME COMPANY is a London-based design company founded in 1984 by Paul White. The company initially worked exclusively on music industry projects, teaming up with a number of well-known artists, including Björk. As the company developed, their client list and type of commissions has diversified. The company is developing a portfolio of work which includes advertising, character design, TV, video, film and the internet. Future projects include working with Jonathan Ive's studio at Apple and designing characters and locations for a game with Sony.

Me Company is an eclectic mixture of designers, directors, copywriters, animators and artists who share a passion for modernity and technology. Being a team is important to them, they all have different skills and bring a wide range of cultural influences into their practice. They demand of themselves that their work is thought-provoking, detailed and entertaining. As a group of people they are driven by a desire to speak powerfully to a visually sophisticated audience.

Me Company's approach is based on being serious about having fun. Their work is intense and they enjoy cultivating strong relationships with their clients. Clients who want to communicate modern ideas and powerful emotions to their customers. Me Company prefer to work for people who share their enthusiasm for new and innovative techniques and they are fortunate to have found the clients who share in their way of thinking about design issues.

Images from the Björk single 'Joga' taken from the album **Homogenic**

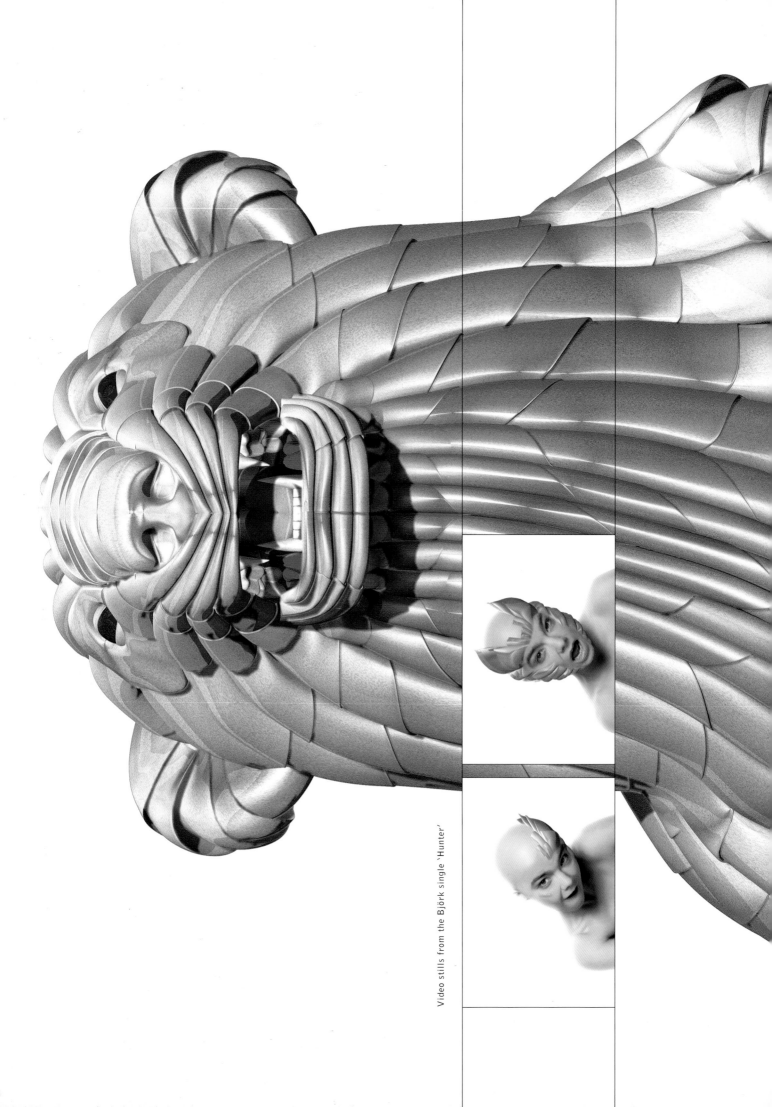

Video stills from the Björk single 'Hunter'

THE PROJECT

Björk **Bachelorette** single taken from the album **Homogenic**

One Little Indian Records

DEVELOPMENT

The only way to truly describe how the 'Bachelorette' single sleeves came to fruition is by illustrating the gradual development of Me Company's sleeve work for Björk, most notably for the 'Homogenic' album.

Me Company has had a long relationship with Björk which is based on trust and being allowed to follow their instincts. 'We have to be able to think that everything is possible and nothing can be ruled out,' they explain. The artwork feeds on discussion, ideas and inspiration. In an ideal situation they get to start thinking about a project well in advance. The artwork for 'Homogenic' is a good example of that. For that project there were some early discussions; three months before Björk started recording in Spain she was telling Me Company about her intention to limit the sonic palette. She was going to manipulate textures on the record so they were distorted as if they were submerged under water. Me Company were interested in something which could symbolize that and started to think of examples; Picasso's Blue Period was one of them. Virtual plants were a link to the computer-generated lotus blossoms on her album 'Post'. Ideas of endoscopic photography crept in and got tangled with Blosfeld's visions of natural strangeness. All of this alchemically was transformed into their final ideas of a monochromatic garden that we all have inside our bodies.

Bachelorette Credits:

Art Director: Paul White; **CG Rendering/Retouching/Cups of tea:** Me Company; **Portait Photography:** Toby McFarlan Pond

79

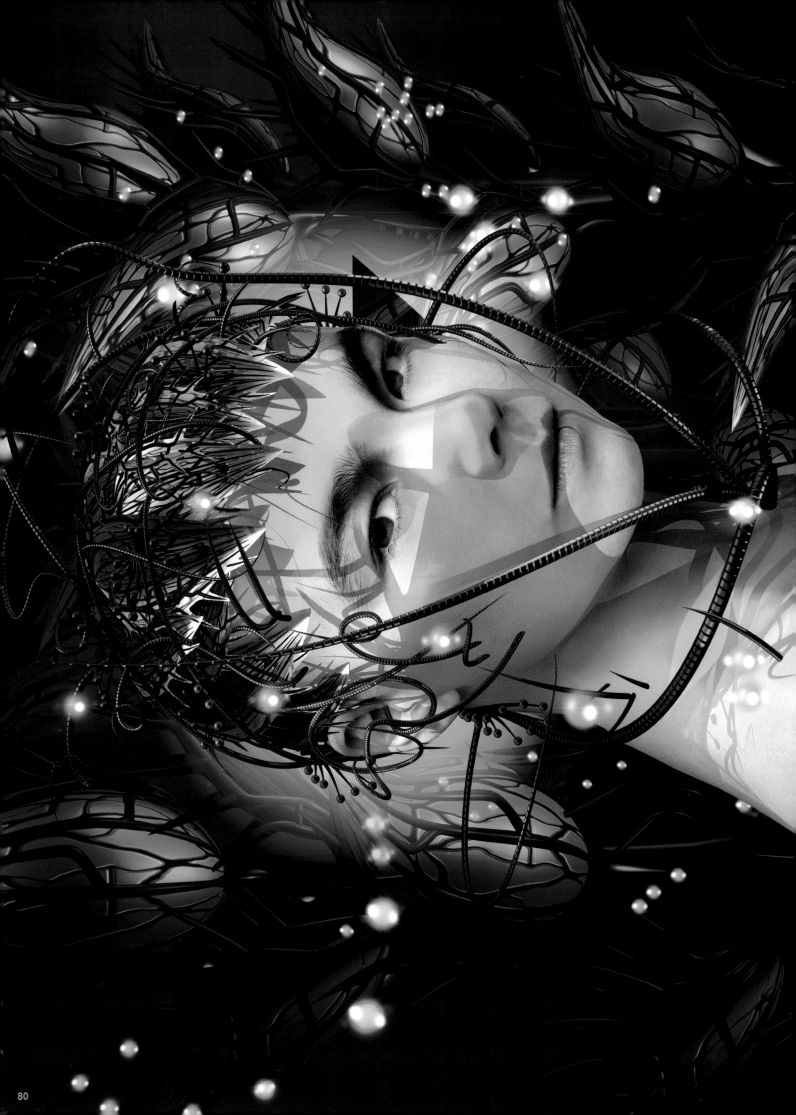

Three panels of the second Björk single sleeve for **Bachelorette**

Björk liked the simple, strong symbolic themes of the previous album sleeves that Me Company had created for her and wanted to keep along those same lines with 'Homogenic'. They discussed the images that Nick Knight and Alexander McQueen had created for 'Visionaire' and one thing lead to another; 'there's no way to draw a map of how it all works,' says Me Company. 'Process is not linear or logical, everything is fluid, ideas talk to each other and change shape. As Björk says, "One plus one equals three." The way Me Company work is based on passion, lateral thought, fuzzy logic and integrity. It's difficult to watch all the moves. It's like a complicated game that you play with an old friend. You both know the rules, but they're difficult to explain and it wouldn't be possible if they didn't share a certain way of looking at things.

'There is a fundamental visual relationship between the photographic image and computer generated materials on 'Homogenic'. It's like a process of unwrapping something... like peeling away the layers to get to an inner core. The red plants are interior pictures of a secret garden that is inside all of us. The character on the cover is presenting a very formal and very strange exterior. That story is repeated in the covers of 'Bachelorette', 'Hunter' and 'Alarm Call'. They are all visions of Björk being caught in the middle of strange transformations.'

Track 1 Written by Björk and Sigurjon Birgir Sigurðsson (Aka Sjón).

Produced by Björk. Recorded by Markus Dravs. Mixed by Mark "Spike" Stent.

Edited by Björk at Syrland Studios, Iceland. Assisted by Ivar Borgir Ragnarsson

and Bjarni B. Track 2 Written by Björk and Mark Bell. Produced by Björk & Mark Bell.

Recorded by Markus Dravs. Mixed by Mark "Spike" Stent.

Track 3 Written by Björk and Guy Sigsworth. Harpsichord by Guy Sigsworth.

Produced by Björk and Guy Sigsworth.

Track 4 Written by Björk and Sigurjon Birgir Sigurðsson (Aka Sjón).

Produced by Björk. Mixed by Howie B.

Tracks 1 & 4 Published by Polygram Music Publishing Ltd.

Track 3 Published by Polygram Music Publishing Ltd (Copyright Control).

Track 2 Published by Polygram Music Publishing Ltd/Warp-EMI Music Publishing.

Cover design by Me Company (www.mecompany.com)

Original Portrait Photography by Toby McFarlan Pond.

Artwork © 1997 Me Company, moral rights asserted and reserved.

The copyright in this sound recording is owned by Björk Overseas Ltd.

under licence to One Little Indian Records and exclusively

licensed to Mother Records for the World

excluding the UK, North America and Iceland.

℗ 1997 Björk Overseas Ltd/One Little Indian Ltd.

© 1997 Björk Overseas Ltd/One Little Indian Ltd.

2121P7OD / Made in England

Three panels of the first Björk single sleeve for **Bachelorette**

'The garden in 'Bachelorette' is incredibly fertile and it is the original home of a character called "Isobel" who features on Bjork's album, 'Post'. Me Company saw the song 'Isobel' as being the birth of a character who represented a kind of unfettered natural innocence and defiance who is living in a modern civilisation. The artwork for the cover of 'Bachelorette' is about that character returning to the garden. She's trying to warn the garden about the dangers of civilization. The plants begin to consume her and try to pull her back to them. They want her for themselves. The image is about a split second of animal beauty frozen on film. It's like a night scene when a flash goes off and you see something in the viewfinder that you didn't expect. What you are seeing is the wild animal inside the very formal person who you meet on the cover of the album.'

'The process is not linear or logical, everything is fluid, ideas talk to each other and change shape.'

'It's like a process of unwrapping something... similar to peeling away the layers to get to an inner core.'

Björk Bachelorette
08 / 12 / 97. CD1 / CD2 / MC

TECHNIQUE / KIT

Paul White and Toby McFarlan Pond went to Iceland and took several pictures of Björk in a small private studio.

In London Me Company were building the CG garden and manipulating a CG model of Björk's head. Selected photographs from the Iceland shoot were then mapped onto the CG model and retouched quite extensively.

Once the CG renders of the gardens were completed all the shadow passes, highlight passes and specular passes were separated out and brought into Photoshop. The composition was then compiled and retouched in Photoshop and saved as a TIFF file for publication.

Layout and graphic design were all done in FreeHand.

HARDWARE (2-D):
PowerMac G3

HARDWARE (3-D):
NT Workstations

SOFTWARE (2-D):
Adobe Photoshop 5
Macromedia FreeHand 8.0

SOFTWARE (3-D):
SoftImage and Mental Ray

Me Company
14 Apollo Studios
Charlton King's Road
LONDON NW5 2SA, UK

Telephone: +44 207 482 4262
Fax: +44 207 284 0402
E-mail: info-axis@mecompany.com
Website: www.mecompany.com (On-line Portfolio)

SEE PAGE 151

Client List:
Apple, Cellnet, Björk, Fuji, Sony,
Camel, Nike, Diet Coke, Aprillia,
Firetrap, Laforet.

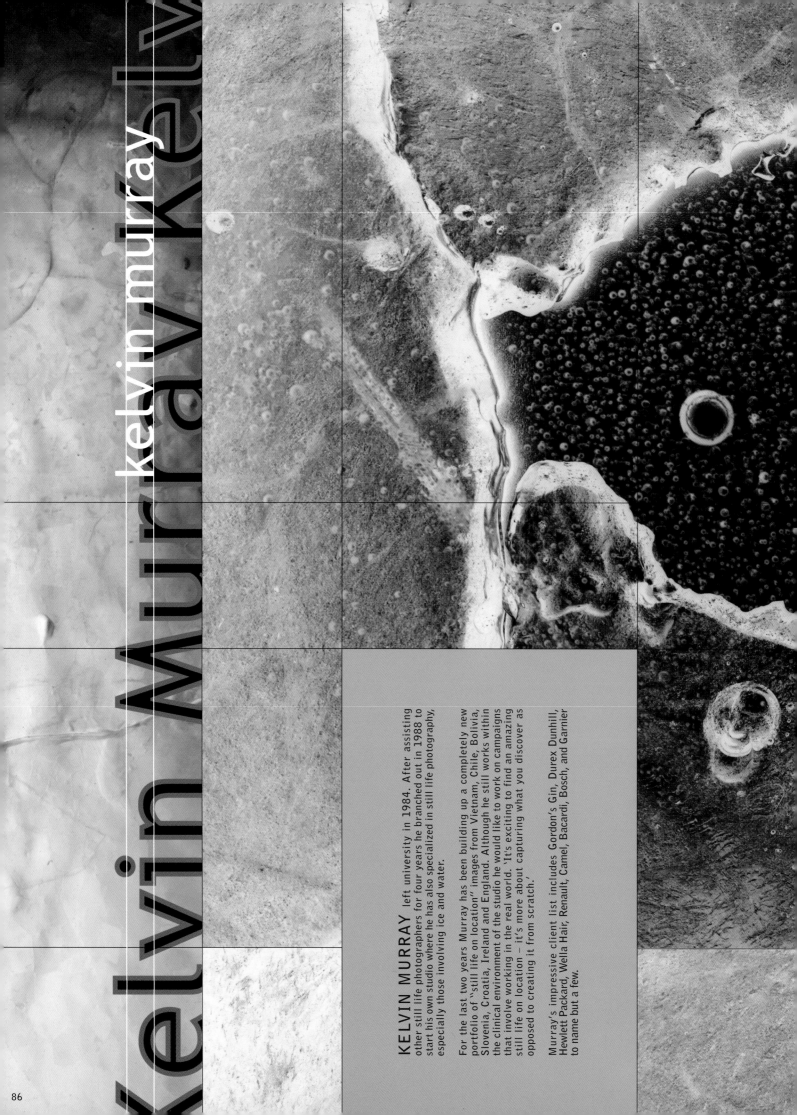

kelvin murray

kelvin murray Kel
Murray Kel

KELVIN MURRAY left university in 1984. After assisting other still life photographers for four years he branched out in 1988 to start his own studio where he has also specialized in still life photography, especially those involving ice and water.

For the last two years Murray has been building up a completely new portfolio of "still life on location" images from Vietnam, Chile, Bolivia, Slovenia, Croatia, Ireland and England. Although he still works within the clinical environment of the studio he would like to work on campaigns that involve working in the real world. 'It's exciting to find an amazing still life on location – it's more about capturing what you discover as opposed to creating it from scratch.'

Murray's impressive client list includes Gordon's Gin, Durex Dunhill, Hewlett Packard, Wella Hair, Renault, Camel, Bacardi, Bosch, and Garnier to name but a few.

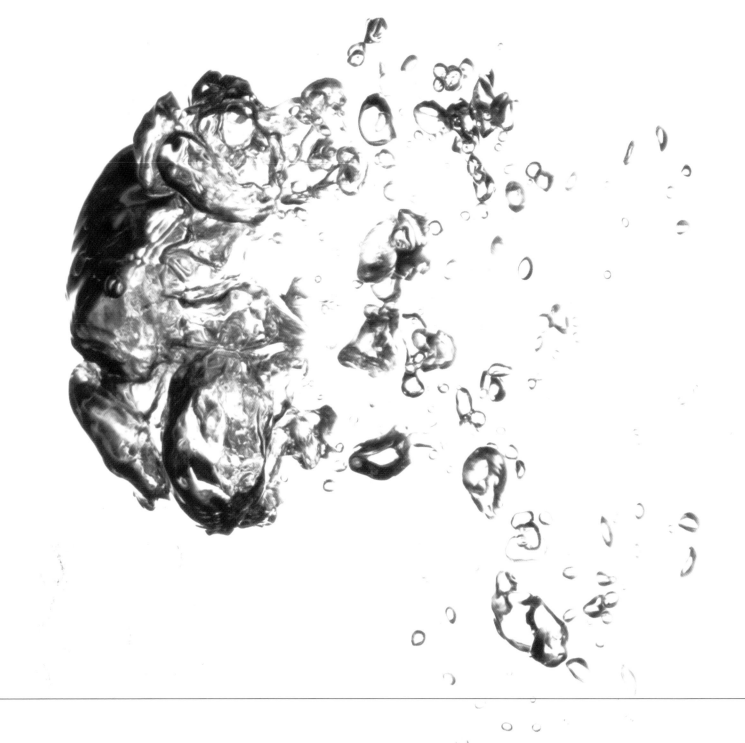

THE PROJECT

To create two ads for **Gordon's Gin.**

BACKGROUND / BRIEF

Kelvin Murray was approached by art director Robin Smith to photograph this series of ads for Gordon's Gin. Stuart Calder (the computer image specialist for the project) had worked with Murray before and suggested that Smith look at Murray's portfolio. Smith was particularly interested in Murray's shot of a crab in ice (see the gallery section).

Based on classic M.C. Escher drawings, Smith wanted to emulate those images in ice. He looked through several photographers' books and for the most part they all wanted to create the ice effects digitally or through models. It wasn't until Smith and Murray shared a few pints at a local pub that Murray convinced him that the best way to approach this project was by trying to create as many of the elements as possible for "real". 'Ice and water are fantastic materials to work with – and very hard to recreate anything believable by model-making,' says Murray.

Project Credits:

Photography: Kelvin Murray
Computer Image Manipulation: Stuart Calder (Lifeboat Matey)
Art Direction: Robin Smith (Leo Burnetts)
Model-maker: Matthew Wurr
Ice Supplies: Duncan Hamilton

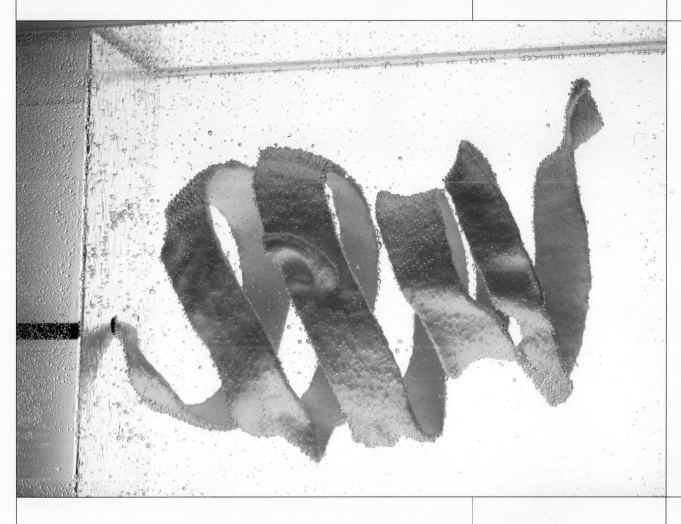

'I wanted these images to be refreshing, unusual, beautiful and a little startling.'

Working photographs for **Lemon head**

DEVELOPMENT

The project began with Murray doing test photographs of ice. An ice sculptor, Duncan Hamilton, that Murray had worked with in the past provided Murray with an almost endless supply of ice blocks with varying degrees of "bubble action" inside. The freezing process is what controls how bubbly, clear or cloudy the ice is going to be.

Each of the elements (ice, bubbles, water pouring and the models) of the shoot were photographed in the studio. Murray worked on creating oval windows in the ice by thinning the ice with hot sponges and cracking it with hot irons. Once the desired effect was achieved the ice was shot from overhead in large glass tanks. The "Gordon's Gin green" hue was initially simulated by lighting the ice through Gordon's bottles but in the end the hue was added digitally.

Everyday Murray would meet with the art director Robin Smith and show him what he had photographed and talk it through. The hardest thing about this job for Murray was the shooting of so many components. He remembers feeling somewhat detached from the project as more control was handed over to Stuart Calder (digital manipulation). He found it increasingly difficult to visualize how it would look completed. In the end he was spending as much time overseeing the digital retouching as he was shooting in the studio. It seemed to be the only way he could make any sense of the project as a unit.

'When I initially thought the job through, I imagined that the retouching would be just complicated compositing. However, in the end it was a lot more,' says Murray.

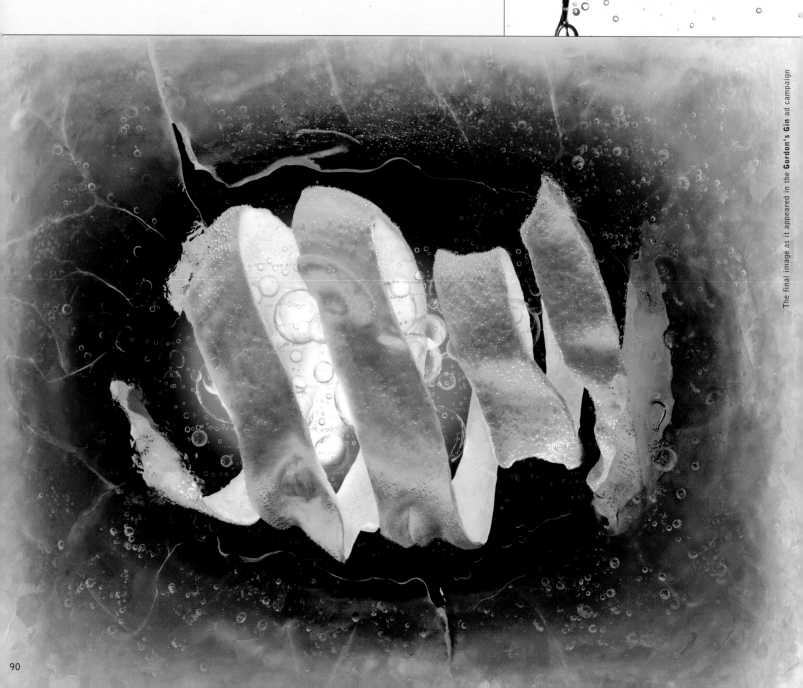

The final image as it appeared in the **Gordon's Gin** ad campaign

90

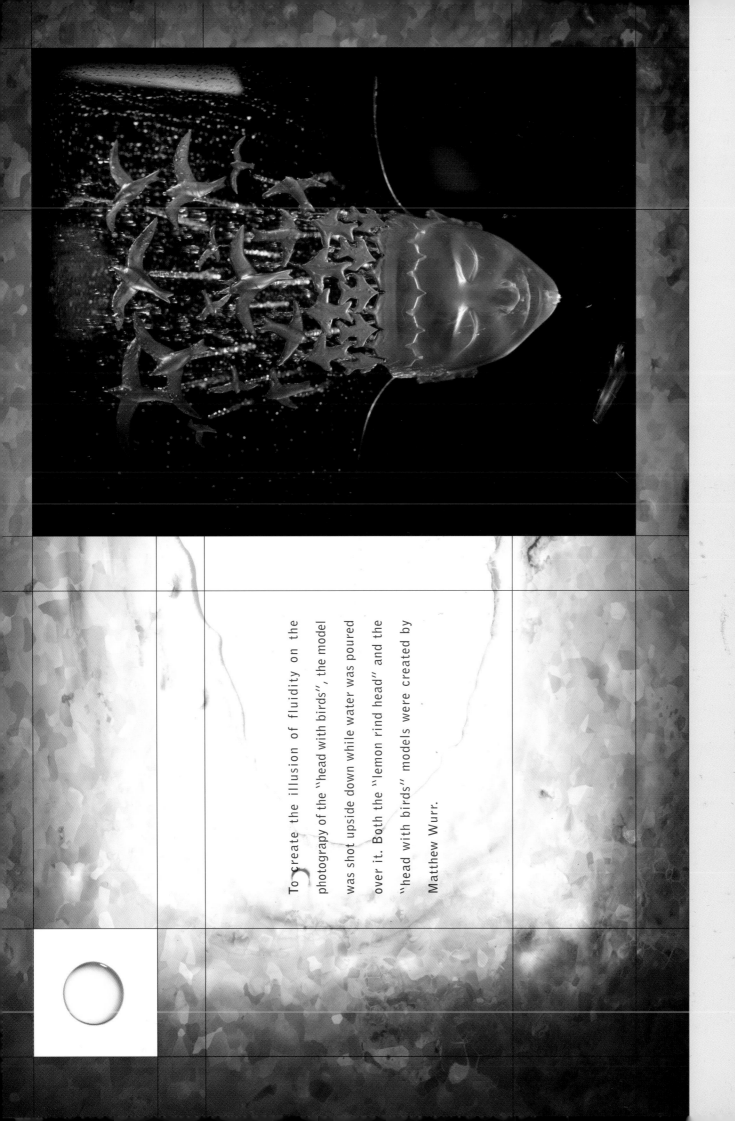

To create the illusion of fluidity on the photograpy of the "head with birds", the model was shot upside down while water was poured over it. Both the "lemon rind head" and the "head with birds" models were created by Matthew Wurr.

'I remember feeling somewhat detached as more and more control was handed over to Stuart.'

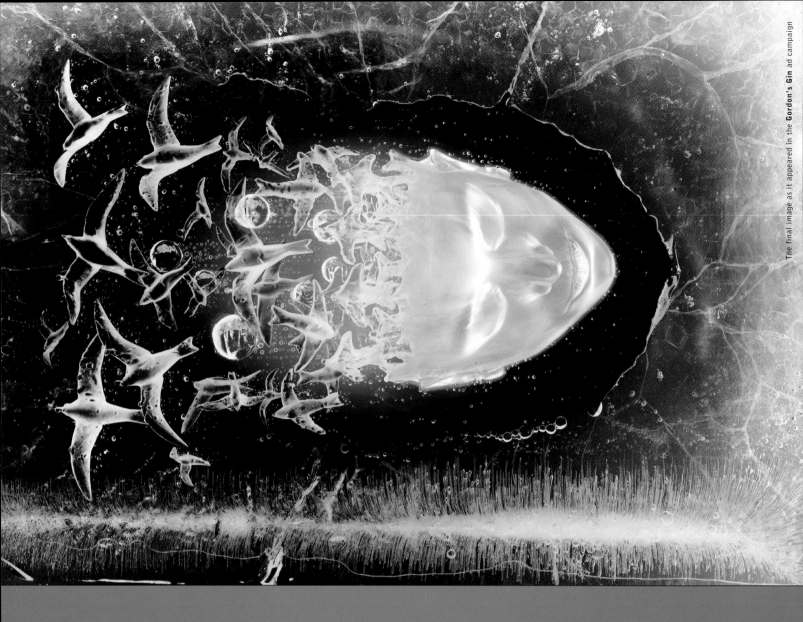

DEVELOPMENT

STUART CALDER (Digital Manipulation)

Calder first envisioned this campaign as a series of simple layouts, but shortly thereafter it was obvious to him that there was going to be a lot of image manipulation necessary. He had worked with Robin Smith before, (e.g. Mercedes, Tanqueray, GinZing and Sanatogen) and had developed a way of working which allowed them the freedom to experiment while still maintaining high standards of production. He had also been working a lot for Kelvin Murray and had seen some of the incredible work he was doing with ice, so he suggested to Smith that they use him for this project.

Initially the client had requested that all the components be shot against white but after many hours, days and weeks into the job they had reached an impasse. For 'Lemon head' they had the construction, composition and the look they were after, but Smith wasn't feeling the response he wanted. 'In such an instance it is often helpful to rapidly alter the image, to provide a fresh eye, either by flipping the orientation, altering the crop or changing the contrast.' says Calder. They managed to get the response they wanted by inverting the hue of the image (making it negative) — the head now took on the appearance of being more thoughtful. Although this solution worked, it also brought with it a new problem for Calder; he had to turn the head, which was now blue, back to its original yellow hue while still maintaining an inverted look. Smith's problem was that he had to sell an image that was the complete opposite of what the client wanted.

TECHNIQUE / KIT

The first step was to bring in different qualities of ice from various transparencies and merge them together. The heads were then pieced together and put in position. The bubbles were added and finally the color work was done.

Stuart Calder can be contacted at:
Lifeboat Matey +44 20 575 7600

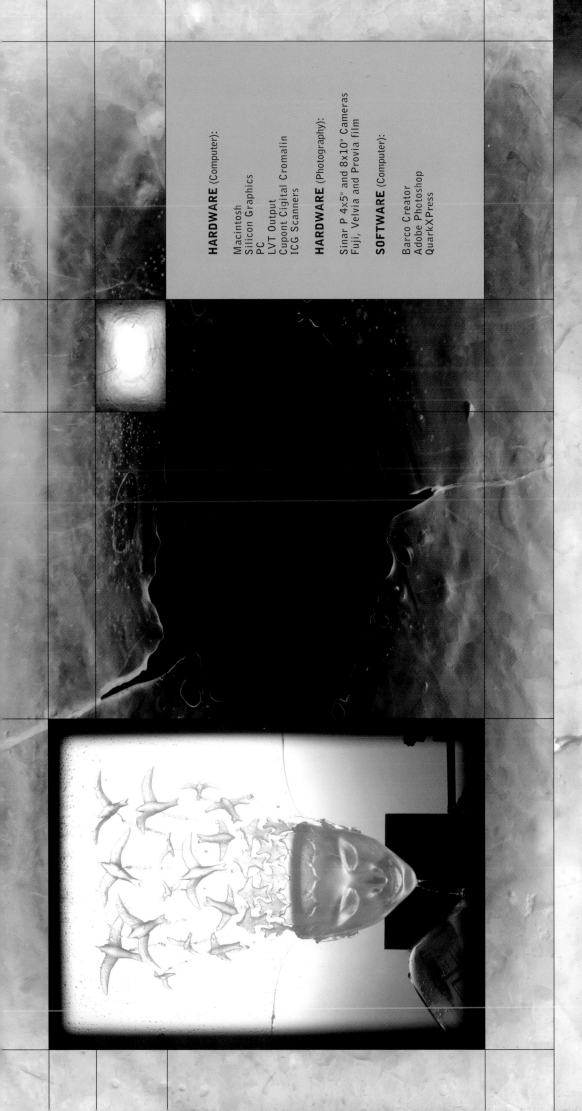

HARDWARE (Computer):

Macintosh
Silicon Graphics
PC
LVT Output
Cupont Cigital Cromalin
ICG Scanners

HARDWARE (Photography):

Sinar P 4x5" and 8x10" Cameras
Fuji, Velvia and Provia film

SOFTWARE (Computer):

Barco Creator
Adobe Photoshop
QuarkXPress

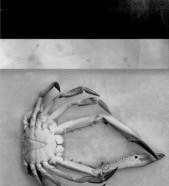
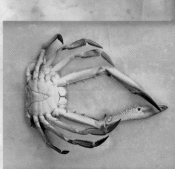

Kelvin Murray
St Lukes Hall
120 Fortune Green Road
London NW6 1DN, UK

Telephone: +44 207 431 5414/5, 07050 130130
Fax: +44 207 435 5315
Email: Kelvin@kelvinmurray.co.uk
Website: www.kelvinmurray.co.uk

SEE PAGE 152

Client List:
Gordon's Gin, Durex, Dunhill, Hewlett Packard, Wella Hair, Scottish Widows, Mulberry, Renault, Camel, Bacardi, Bosch, Garnier, State Express 555, Technics.

robert nakata

robert Nakata

robert nakata

ROBERT NAKATA attended the Ontario College Of Art in Toronto, Ontario, Canada from 1979 to 1983. Between 1983 and 1986 he studied at the Cranbrook Academy Of Art in Bloomfield Hills, Michigan while maintaining his connection with Canada by working for The Dymark Group located in Willowdale, Ontario. In 1986 Nakata moved to The Hague, the Netherlands to accept an internship with Studio Dumbar which he worked with until 1992. Since 1993 Nakata has been with the Amsterdam branch of Wieden & Kennedy.

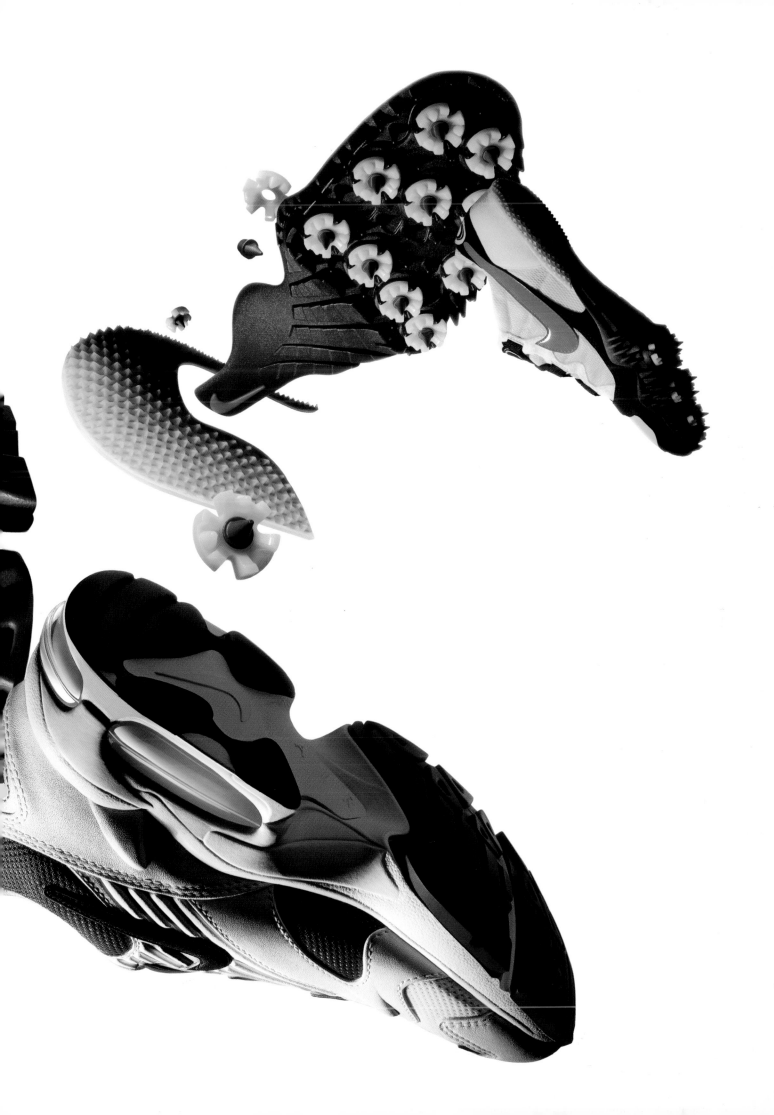

The Air Max Uptempo basketball shoe is for big, fast, crashing-down-from-the-boards-like-a-meteorite kind of players. The earth is protected from them by the most Nike-Air cushioning we've ever put into one sole.

Nike-Air* cushioning will save the earth. One court at a time.

We've put all Nike's athletics experience into a trail-running shoe, the Air Terra Tor. It's light, flexible and cushioned, with enough grip to turn its steepest hill trail into a spent track.

Some people see countryside, we see a stadium.

THE PROJECT

Nike **Product Leadership** Print Campaign

11 single-page print advertisements which ran in various sports and general interest publications (ten of those advertisements are featured here).

BACKGROUND

Nike and Wieden & Kennedy have had a long working relationship which covers a span of over 15 years. As Nike has grown from a small US company based in Beaverton, Oregon to a worldwide sports company, Wieden & Kennedy have progressively opened offices in different regions to create the communications (television and print) for Nike locally and internationally.

BRIEF

In its efforts to make the best-performing equipment for athletes, Nike prides itself on the research and development which goes into its shoes. The innovative and leading technology it invests is often overshadowed by the athletes and Nike wanted to give the technology its own platform. 11 shoes covering a range of sports were identified as embodying their top technology and design (at that time) and were to be featured in some manner in the communication.

Project Credits:

Agency: Wieden & Kennedy, Amsterdam
Creative Direction: Michael Prieve, Bob Moore
Art Direction and Design: Robert Nakata
Copywriting: Giles Montgomery
Photography: Hans Pieterse
Digital Post-production: Souverein/Jeroen
Print Production: Pieter Leedertse

DEVELOPMENT

Originally Nike had tried to run a campaign in Europe which had been developed for the US. This US campaign featured several shoes photographed individually on a plain white background accompanied simply by a 1-800 number. Upon calling the toll-free number, a caller heard the voice of an athlete who spoke about the shoe and his or her sport. At that time in Europe toll-free numbers had just been introduced and, consequently, many Europeans were unaware of the concept of no-cost telephoning and therefore few called. As Nike still wanted to communicate its innovative technology, the following campaign would require a different approach. One obvious aspect of the shoes was the way they looked. The 11 in particular looked like no others and given the amount of development, they performed like no others. One thought emerged that these shoes were in a world of their own and it was decided to show them as such. Given the details on the shoes, they could be visually taken apart to create a universe based on the particular shoe.

In the battle
of the sexes
Nike trains
both sides.

NIKE AIR

Because feeling good doesn't have a gender we made the Air Max Structure workout shoe for women. And to keep you fit for battle we made the shoe super-cushioned with Nike-Air® units.

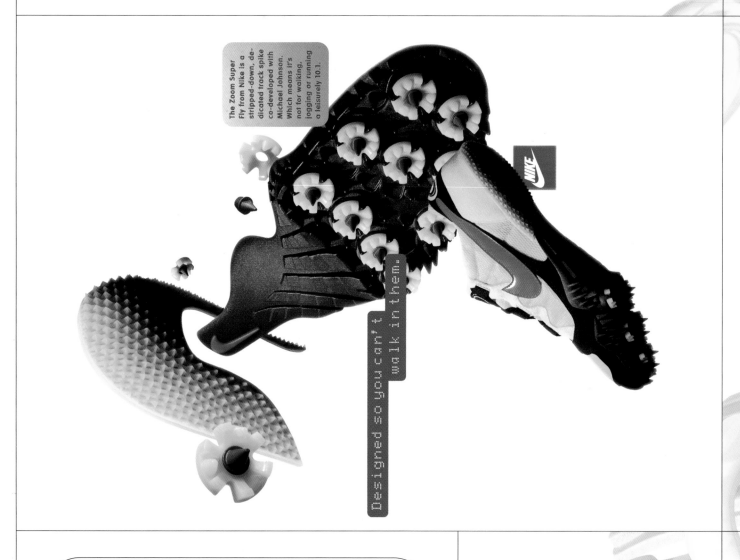

The Zoom Super
Fly from Nike is a
stripped-down, de-
dicated track spike
co-developed with
Michael Johnson.
Which means it's
not for walking,
jogging or running
a leisurely 10.1.

Designed so you can't
walk in them.

NIKE

TECHNIQUE / KIT

Initially the shoes were roughly photographed from innumerable angles and the various details were scanned and cut out in Adobe Photoshop. While rough compositions were initialized in QuarkXPress, most were composed in layers in Photoshop. Some copy concepts were already worked out, some were altered and/or inspired as the computer sketches progressed. Some of the featured details were overtly functional, others were superficial, but all parts were derived from each individual shoe. Once the rough computer layouts had been finalized, presentations were made with color laser prints and after final concepts and budgets had been approved, final photography started. As the shoes were prototypes some of the details on the shoes had not been finalized. Also, the shoes were not made entirely of physically different parts; some of the apparently separate shoe forms were articulated with color only. It was clear that the "parts" would have to be created through a combination of camera and computer (in this instance, the Paintbox). Entire shoe parts, backsides and insides of parts had to be made up from other details and/or from a "palette" of photographs made specifically for colors and textures only. In order to create the illusion of a singular environment the positioning of the elements had to be worked out beforehand specifically so that the various objects could be lit and photographed to look as if they were illuminated in the same environment and with the same light source. The shoe and its details were photographed with black paper surround to control light levels and resolution; reflected white light "halos" had to be digitally added to the objects afterwards to make them float convincingly within the artificial white environment.

98

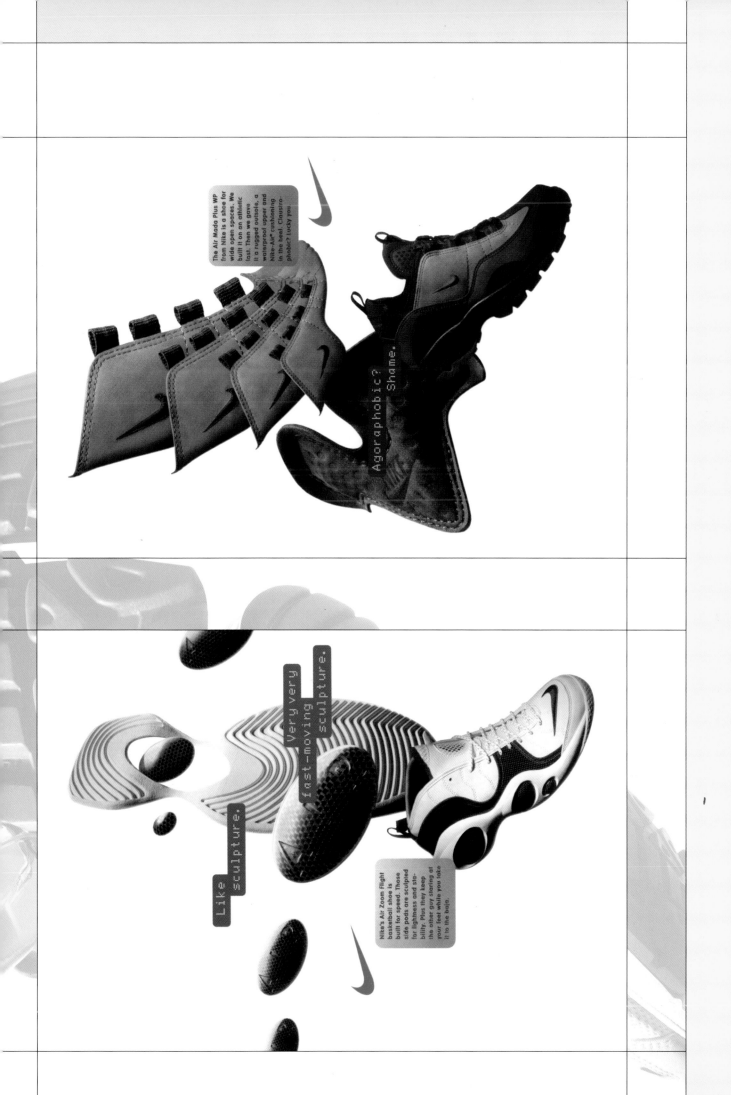

'It was clear that the "parts" would have to be created through a combination of camera and computer.'

Above: 'The shoe and its details were photographed with black paper surround to control light levels and resolution; reflected white light "halos" had to be digitally added to the objects afterwards to make them float convincingly within the artificial white environment.'

WORKING WITH PHOTOGRAPHY

'In working with photography for design and advertising, I find I end up in two general areas: one where it is used as base material for digital manipulation and second, where the photograph is used essentially in its pure form. I do not place a greater value on either but attempt to channel the photography could be from any level of imaging (Polaroid, video still, toy camera, etc.), but is usually high-resolution camera work which captures a subject/object, texture, color or a movement. The photographic elements are then further adjusted and/or converged in the computer based on the specific communication brief. Beyond that overt task, the intent is to then create a world where type, graphics and photography feel totally integrated, either literally as objects massed together or passively as levels within a composition. Ironically, my awareness of the subtler qualities of photography has been raised by digital processing. The reason for this is that by virtue of being able to change almost anything, everything is scrutinized. However, there comes a point where there is too much manipulation. It is not a fixed borderline but it is unique to each photographic element. When you go past that line and compare it to where you started from, you realize more so that photography brings with it its own coherent world where many decisions have been taken care of. While digital scrutiny can be a wondrous and seamless creative extension, it can be a daunting task to match the spirit of the unaltered photographic image. In these instances photography is used in its more-or-less unaffected form.'

Before Nike, people walked.

Running took off just after we started making running shoes. We're still innovating: the Air Max Light is our most cushioned lightweight running shoe yet. Okay, enough history. Go run.

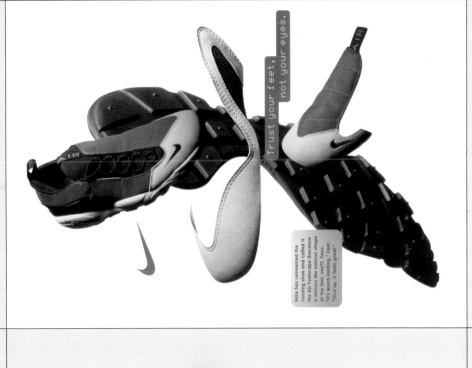

Trust your feet,
not your eyes.

Nike has reinvented the running shoe and called it the Air Footscape (because it mirrors the natural shape of the foot, swft). Eyes. "It's weird-looking." Feet: "Shut up. It feels great."

Criar Arrasar

Just do it

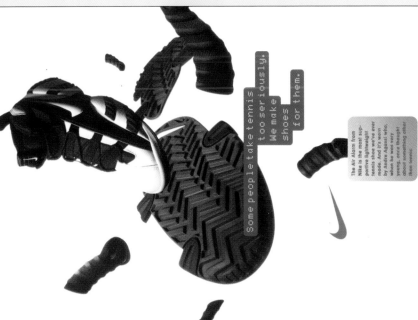

Some people take tennis too seriously. We make shoes for them.

The Air Alarm from Nike is the most supportive lightweight tennis shoe we've ever made. And it's worn by Andre Agassi who, whom he was very young, once thought about something other than tennis.

Benelli A91

HARDWARE (Computer):

PowerMac 9600/233
Xerox 5790 color printer/scanner

HARDWARE (Photography):

Olympus OM-2n 35mm Camera
Various lenses

SOFTWARE (Computer):

Adobe Photoshop 5.0, 5.1
Adobe Illustrator 7.0
QuarkXPress Passport 4.04

Robert Nakata
Wieden & Kennedy
Keizersgracht 125–127,
1015 CJ Amsterdam, the Netherlands

Telephone: +31 20 621 3100
Fax: +31 20 621 3299
E-mail: robertn@wkamst.nl

SEE PAGE 153

Client List:
(Wieden & Kennedy worldwide) Nike, Audi,
Miller Beer, HypoVereinsbank, ESPN, Coke,
Brand Jordan, Oregon State Tourism.

ONE9INE is a design company specializing in visual communications for print, broadcast and interactive media. Partners Warren Corbitt and Matt Owens, both graduates from the Cranbrook Academy of Art's Design Department, share a broad and in-depth knowledge ranging from editorial redesign, brand identity development, website development, consulting, and creative direction. Seeking to play in the space where divergent media begin to commingle, one9ine is after exploiting the very space that traditional media categorization aims to disqualify.

Warren Corbitt has a strong editorial background working with clients such as 'GQ', Condé Nast, 'House & Garden' and 'Esquire' and was the founding art director at Swoon.com and the lead art director at CKS Site Specific. Warren co-designed 'WhereIsHere' with P. Scott and Laurie Haycock-Makela, published by Lawrence King, and also worked on broadcast animations for MTV Networks with P. Scott Makela. Most recently Warren co-designed the redesign of 'RayGun' magazine. Warren's work has been recognized by the Society of Publication Designers, ID Annual Design Review, as well as multiple domestic and foreign design publications.

Matt Owens served as the creative director at web developer MethodFive in New York, designing websites for clients such as Apple, the American Lung Association, and Toshiba among others. In 1997 Matt launched VolumeOne, a design studio dedicated to exploring narrativity on the internet and to pushing the limits of available design technologies online. In turn, VolumeOne brought an integrated, cross-media approach to projects such as the Crittercam Chronicles feature for 'National Geographic''s website, as well as developing content features for Altoids, Razorfish and Quokka Sports. Matt's work has been published in the pages of 'Eye', 'Emigre', '+81', 'IDN', and 'ImgSrc100'.

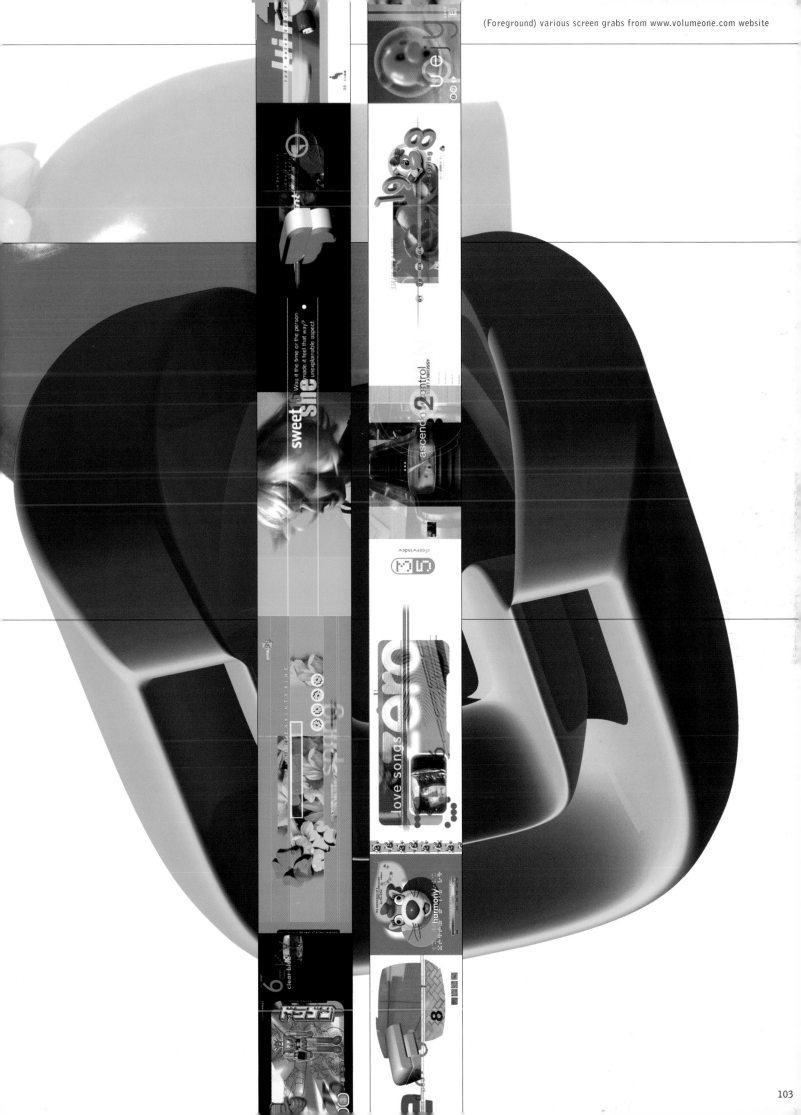

BACKGROUND / BRIEF

Skooby Laposky, the artist behind the Oratai project, approached Warren Corbitt about designing his CD, a combination of personal audio exploration and implementation of his graduate thesis at Cranbrook Academy of Art. Laposky and Corbitt had developed an artistic relationship over the previous two years, with Laposky collaborating on audio for Corbitt's video projection-based installations. During that period they had developed an extremely collaborative rapport – so needless to say it just felt natural for them to work together on this project. What one might call a dream client.

PROJECT **ONE**

Oratai **D3R17** CD Sleeve
Independently Produced

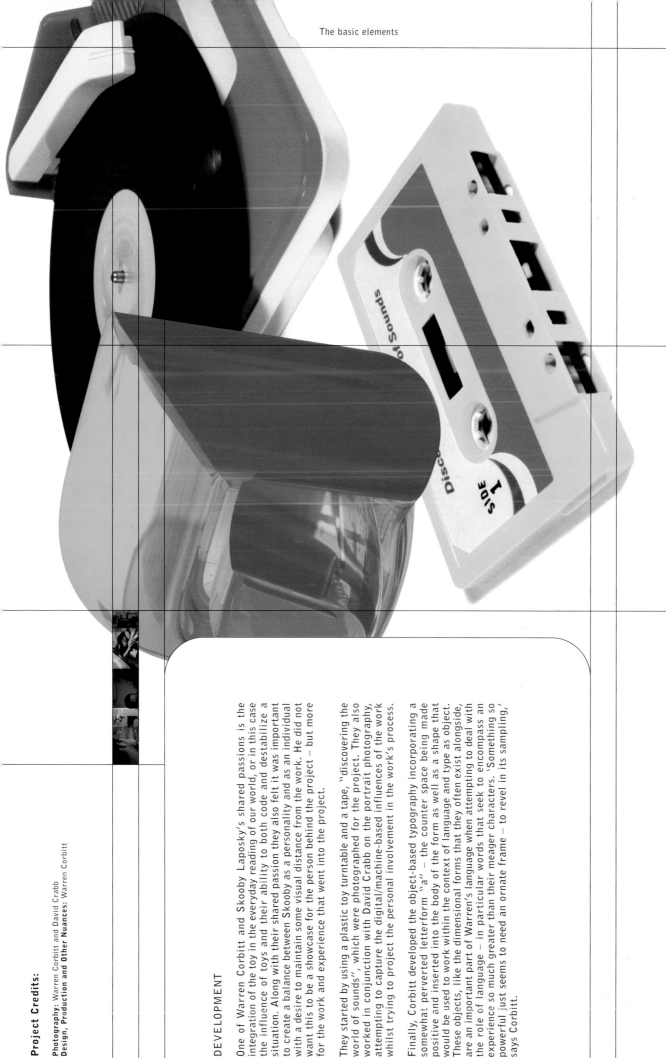

Project Credits:

Photography: Warren Corbitt and David Crabb
Design, Production and Other Nuances: Warren Corbitt

DEVELOPMENT

One of Warren Corbitt and Skooby Laposky's shared passions is the integration of the toy in the everyday reading of our world, or in this case the influence of toys and their ability to both code and destabilize a situation. Along with their shared passion they also felt it was important to create a balance between Skooby as a personality and as an individual with a desire to maintain some visual distance from the work. He did not want this to be a showcase for the person behind the project – but more for the work and experience that went into the project.

They started by using a plastic toy turntable and a tape, "discovering the world of sounds", which were photographed for the project. They also worked in conjunction with David Crabb on the portrait photography, attempting to capture the digital/machine-based influences of the work whilst trying to project the personal involvement in the work's process.

Finally, Corbitt developed the object-based typography incorporating a somewhat perverted letterform "a" – the counter space being made positive and inserted into the body of the form as well as a shape that would be used to work within the context of language and type as object. These objects, like the dimensional forms that they often exist alongside, are an important part of Warren's language when attempting to deal with the role of language – in particular words that seek to encompass an experience so much greater than their meager characters. 'Something so powerful just seems to need an ornate frame – to revel in its sampling,' says Corbitt.

TECHNIQUE / KIT

The toys were shot with a Nikon F3 camera with a macro lens. All portrait photography was shot on high speed slide film. Everything was scanned using a Polaroid Sprintscan then color corrected in Photoshop 4.0. The type was set in Adobe Illustrator 7 and the dimensional type was modeled and rendered in Strata Studio Pro 2.5. Final page compositions were created in QuarkXPress 3.32 then output to film with a Kodak matchprint.

PROJECT **TWO**

SUMMER – THE TARMAC

VolumeOne Website Pages and Promotional Materials

This page: front of postcard for promoting VolumeOne website

Project Credits: Photography and design: Matt Owens

BACKGROUND

As part of Matt Owens' ongoing personal project, VolumeOne, this summer issue uses images of slot cars to communicate the hot summer season. Slot cars have strong associative qualities with childhood and are used in this instance to allude to notions of speed and the carefree nature of "play".

DEVELOPMENT

The photographs were taken using both a Polaroid SX-70 for still shots and a Sony DSCF-1 digital camera for the animated sequences of the cars. After a pool of photographs was developed the editorial was formalized and design iterations began.

TECHNIQUE

Most of the work was mocked-up in Photoshop until layouts and basic structure were finalized. Using the mock-up as a foundation, images were segmented, optimized and animated for presentation online. Html and javascript were used to create a small pop-up window and to tie the pieces together to create an inclusive online experience.

Three screen grabs from the VolumeOne website

[well, as well as any CLOWN can see]

PROJECT THREE

SEESELF

Graduate thesis page for Cranbrook Academy of Art

BACKGROUND / BRIEF

This is a page from Warren Corbitt's graduate thesis at Cranbrook Academy of Art. 'I didn't really have much choice about doing the project, but had way too many choices as to what to focus on. One of the joys — and sometimes curses — of a Cranbrook graduate design education is the lack of the classic educational "assignment". The only directive is you have got to make it meaningful,' says Corbitt.

The majority of Corbitt's work at Cranbrook dealt with the role of the toy in modern communication and also our modern relationship with the world and our body's interaction with that space. Extending past Freud's "little boys get construction sets, little girls get dolls", Corbitt was seeking a space where Jill did not always let Barbie keep her head, and Jack did not always keep his purity. Within that space the shared foundation is based on the discursive relationship of the sampled elements.

Corbitt asks, 'If we are to accept the body as construction [i.e. with a lack of essential elements that drive gendered representation as a sovereign body] then how do we talk body? How does one enter stage right as gendered body without cementing gaze on dogma? How does one even discuss body without reifying it as a ONE?'

'Who can argue with the happy clown, or more importantly if you did, could you tell if he was upset?'

DEVELOPMENT

Corbitt's goal was to create a space of voyeuristic reversal with the clown taking on almost epic proportions on the page. "We are used to treating our toys as object – that is safe – but what happens when that role is subverted? What transpires when the toy and viewer are of the same scale – yet the relationship is not? What happens when we become like the two year old, the separation between toy and self not so evident or spelled out? What happens in that space?' asks Corbitt.

'Starting with a clown, the language of SEE and SELF, and the phony phonetic shared space of the SEE, I began playing with the letter "C" as a link between the two spaces. It is obviously not a direct bridge, but more of a site-line to help connect the idea of vision and relationship to that outside of us, and then the resultant formation of what we consider our SELF,' explains Corbitt.

'Dimensional typography has been an aid in this exploration for some time – a means of creating an objectified language that immediately calls question to itself. Can it simply be read? Or do we, by considering its surface, also begin to question the existence of voice through its inclusion and placement in the work? My work at Cranbrook with P. Scott Makela was pivotal in this exploration – his desire to see the insides of the letters, in both a figurative as well as subjective manner – influencing and propelling my personal exploration into these powerful and suggestive forms,' he concludes.

TECHNIQUE / KIT

The clown was shot with a Nikon F3 camera with a macro lens. The image was scanned using a Polaroid Sprintscan then silhouetted and color corrected in Photoshop 4.0. The type was set in Adobe Illustrator 7 and the dimensional type was modeled and rendered in Strata Studio Pro 2.5. Final page compositions were created in QuarkXPress 3.32 then output to a Designwinder digital printer.

The basic elements

Project Credits:

Photography: Warren Corbitt
Design, Production and Other Nuances: Warren Corbitt

Learning the parameters. Acquiring the fundamentals.
There is a physics behind the phenomenon.

A sense of hesitant
A scrambling effort

[5:35:24 pm. quick s
mortal terror ->

PROJECT **FOUR**

DEEP END

VolumeOne Website Pages and **Emigre** Magazine Spreads

sink or

mplex equations. suffocated.

Project Credits: Photography and design: Matt Owens

up for

Forever the novice. An enthusiastic hobbiest.
Close yet now yet unattainable
Buoyant insight. unsurfaced.

[06:36:07am. morning lighting]

<-- A provisional sense of accomplishment gives way to a sinking feeling that something has been left undone. -->

DEVELOPMENT

'The creative endeavor is a cyclic one. Keeping your head above water and learning the parameters is the process we endure as enthusiastic hobbyists. This piece is a companion to spreads that appeared in Issue 51 of 'Emigre' magazine.

'The intention behind the project was to use both web and print to explore a conversation between media. The spreads deliver a kind of commentary on a 24 hour period in which a creative process occurs. The online experience responds to the five spreads as interactive sections and picks up narrative threads where the print companions left off. Ideally one would have the spreads in hand and also be encouraged to go online and see how the physical object and the screen-based experience interrelate.'

Two-page spread from **Emigre** magazine

Learning the parameters. Acquiring the fundamentals.
There is a physics behind the phenomenon.

sink or

Complex equations. suffocated.

<!-- A sense of hesitant regret clouds the previous moment.
A scrambling effort to find footing merges with an acute sense of mortal terror. -->

[5:3:52:4pm. quick shower.]

Two-page spread from **Emigre** magazine

THOUGHTS ON PHOTOGRAPHY

'Text and image relationships provide the foundation of graphic design and the use and creation of photography is a fundamental component in our creative process.

In our work, we have been using Polaroids, video, 35mm and digital cameras as a way of researching and documenting the world around us. Having a camera on hand at all times encourages one to immediately capture moments and images that are interesting and meaningful.

In addition, the camera is also an extension of the creative voice. From video installations to web-based explorations, photography becomes the subject and object, one of the many characters that act out the visual narrative of the work.

Photography as both document and instrument informs personal and client work, as well as reflecting our way of seeing the world. As graphic designers, photography serves as the armature upon which typography is harnessed. In this manner, the photograph as well as the literary component of a project provides the catalyst for communication. All visual language is only as intelligent as the subject matter and raw materials used. By being actively involved in the articulation of the editorial, typographic and imagistic aspects of any project, one can choreograph these players of visual communication, be it on screen or on surface.'

HARDWARE (Computer):

PowerMac G3/333 – 9 gigs
384 megs of RAM
IXMicro Ultimate Rez Video Card
Mitsubishi 91TXM 21" monitor

HARDWARE (Photography):

Nikon F3 and Polaroid SX-70 Cameras
Sony DSCF-1 Digital Camera

SOFTWARE (Computer):

Adobe Photoshop 4.0
Adobe Illustrator 7
QuarkXPress 3.32
Strata Studio Pro 2.5

one9ine
The studio of Warren Corbitt and Matt Owens
54 West 21st Street, Suite 607
New York City, New York 10010, USA

Telephone: +1 212 929 7828
Fax: +1 212 645 3409
E-mail: warren@one9ine.com | matt@one9ine.com
Website: www.one9ine.com

SEE PAGE 154

Client List:
'GQ' (UK), Condé Nast, 'House & Garden' (UK), 'Esquire' (USA), MTV, 'RayGun' (USA), Apple, The American Lung Association, Toshiba, 'National Geographic', Altoids.

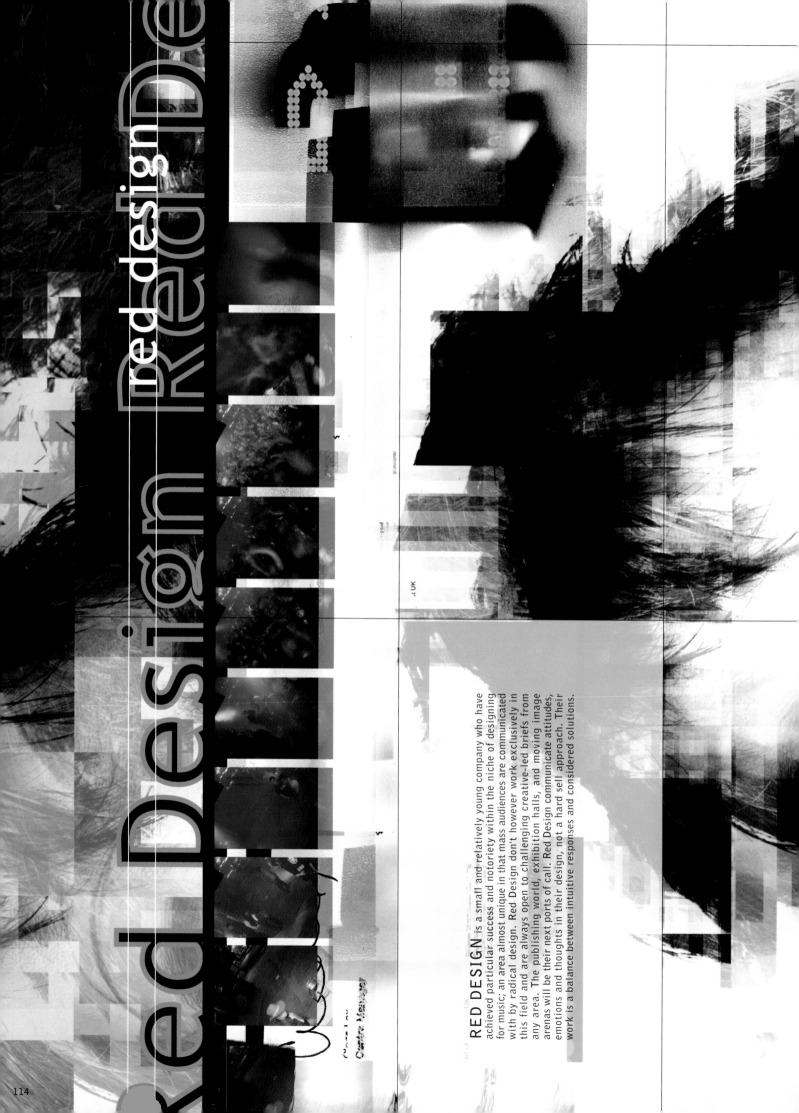

Red Design
red design
Red Design
Red Design

RED DESIGN is a small and relatively young company who have achieved particular success and notoriety within the niche of designing for music; an area almost unique in that mass audiences are communicated with by radical design. Red Design don't however work exclusively in this field and are always open to challenging creative-led briefs from any area. The publishing world, exhibition halls, and moving image arenas will be their next ports of call. Red Design communicate attitudes, emotions and thoughts in their design, not a hard sell approach. Their work is a balance between intuitive responses and considered solutions.

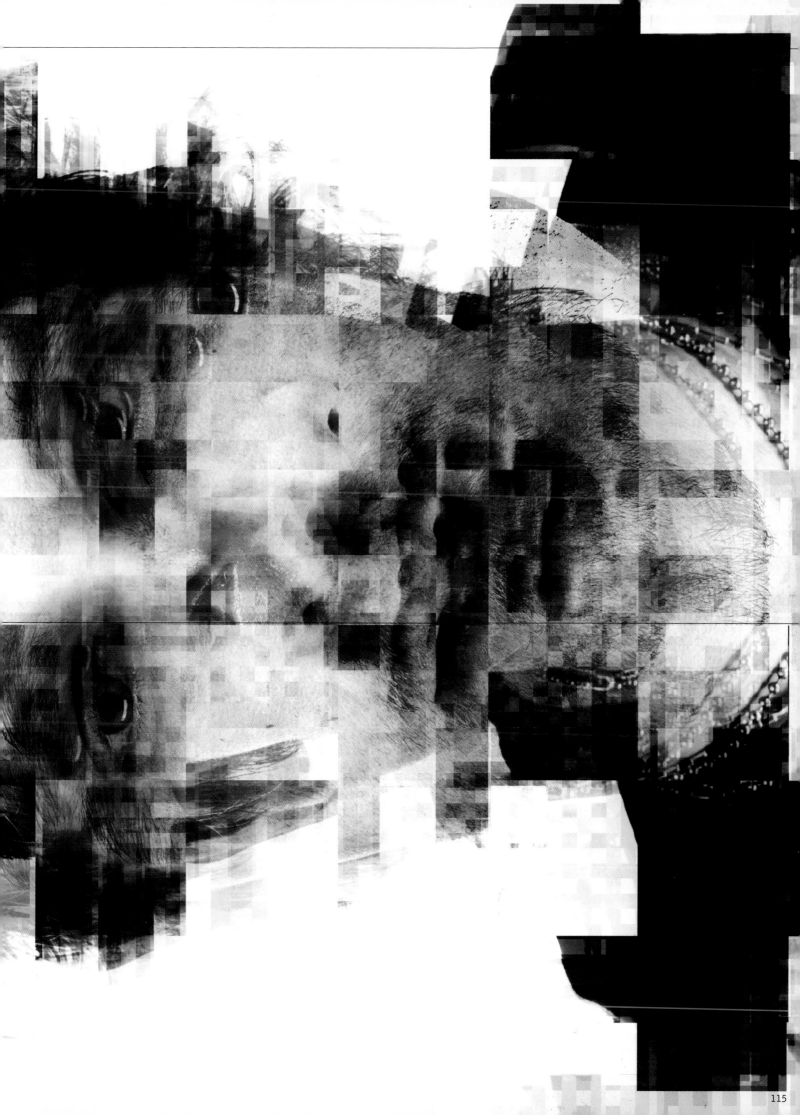

PROJECT ONE

Super_Collider (aka Cristian Vogel and Jamie Lidell) **Head On** album sleeve for Loaded Records

Project Credits:

Creative Directors: Hamish Makgill and Ed Templeton (Red Design), Mat Consume, Cristian Vogel and Jamie Lidell (No-Future)
Photography: Ben Cowlin
Art Direction and Design: Ed Templeton and Hamish Makgill
Logo Design: Mat Consume

THE BRIEF

Red Design work in the same building as No-Future (Cristian Vogel's production company) and have been known to have a shandy or two after work together. They heard the very early tapes of Cristian Vogel and Jamie Lidell's collaboration and advised them to go to Loaded Records, they have been involved with Super_Collider ever since. Once releases were imminent Red Design got together with Mat Consume (No-Future's 3-D/moving image artist), Vogel and Lidell to thrash out ideas.

The record company was happy to leave it up to them – especially as they were aware of No-Future's anarcho-syndicalist tendencies and track record of underground success. It was important to reflect the originality of the music, its defiant non-commerciality and its creation through highly synthesized experimental electronic processes while maintaining an organic feel. One thing they all agreed on was that they wanted to feature both artists on the sleeve (as the project was a departure from the normal faceless techno genre they both worked in) but not in the typical representational way.

DEVELOPMENT

The word from Loaded records boss Tim Jeffrey was to create "the best album cover of the decade" which is always a difficult task to fulfil.

By creating a simple yet arresting front image and taking a cleaner, more considered approach on the production of the idea and the presentation of the information, Red Design simplified the cover compared with the previous singles. This approach is one they often use when producing album artwork. They chose to use a two color print process using a brass metallic ink to create a futuristic sepia tone. To reverse the idea of having the artwork directly printed on the sleeve, they designed a removable sticker to convey all the vital information which would be stuck on top of the cover artwork and wrap around to the back of the sleeve. The idea of fragmenting images of Vogel and Lidell was taken to its conclusion by constructing one person from the two images. For the images Red Design commissioned Ben Cowlin to take highly detailed, evenly lit portraits of Cristian and Jamie with their heads in exactly the same position to allow them to combine them more easily.

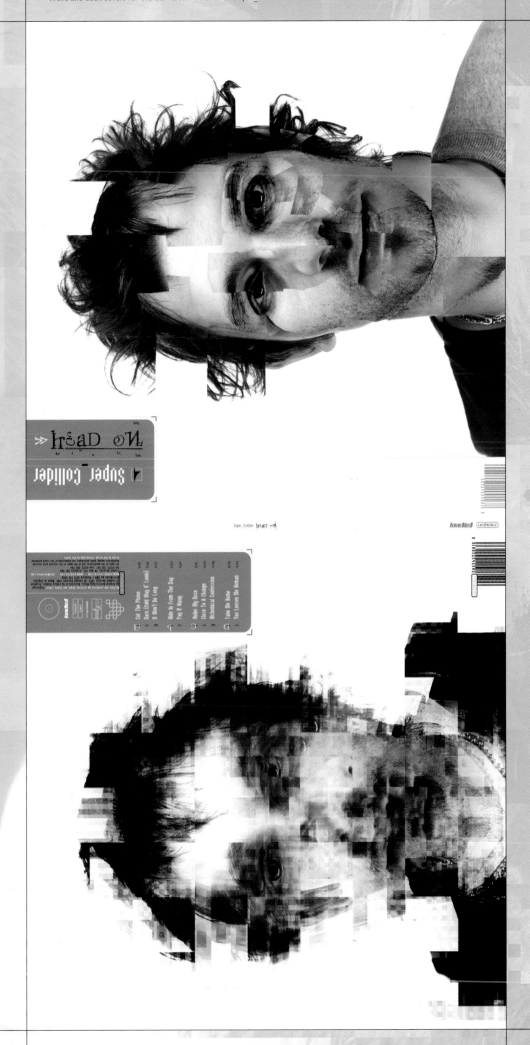

For the front cover Poser was used to 3-D map both faces, these maps were then placed in Photoshop to use as a template to ergonomically cut and replace different sections of the two portraits. The results leave the viewer with a disturbing yet organic interpretation of the combined artists. The blending of the two portraits for the back was done in Photoshop using the wavelength filter, this created a synthetic combination reflecting the two sides of the music.

TECHNIQUE / KIT

Vogel and Lidell were photographed using medium format black-and-white film in a controlled evenly lit studio environment. These were hand-printed on 12 x 16" paper and then scanned on a drum-scanner. For the front cover, a 3-D map was created of each face using Poser and then used as templates in Photoshop. Using Lidell's face as a base, ergonomic sections of Vogel's head were placed within the contours of Lidell's face until an unearthly amalgamation was created. The back cover was created by overlaying images of both Vogel and Lidell which were then distorted using the wavelength feature in Photoshop. This wavelength distortion was pushed further and overlaid with images of Vogel and Lidell to create a digital texture for the inside sleeves. Six other amalgamations of Vogel and Lidell taken from stages of creating the front and back images were used as icons on the inside next to the untreated photographs of the artists.

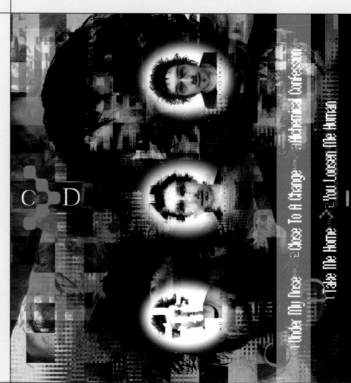

PROJECT TWO

Super_Collider (aka Cristian Vogel/Jamie Lidell) **It Won't Be Long** single sleeve for Loaded Records

Project Credits:

Creative Directors: Hamish Makgill and Ed Templeton (Red Design), Mat Consume, Cristian Vogel & Jamie Lidell (No-Future)
Graffiti backdrop: Pablo Fiasco and Jason Brashil
Photography of graffiti session: David Breckon
Other Photography: Ed Templeton
Art Direction and Design: Ed Templeton and Hamish Makgill

Front of sleeve

'The original photo of the piece seemed too garish to use on the cover, so it was digitally toned down and chopped up using layers in Photoshop.'

Complete sticker for Super_Collider's 12" single **It Won't Be Long**

The other front

DEVELOPMENT

The second single from Super_Collider is a double-A side. Placing the sticker of the artwork over a raw unfinished 12" jacket, Red Design created a cover with an interchangeable front. Each half of the sticker (which wraps around the sleeve) represents one of the tracks and either side can act as the front cover. A graffiti piece (by Pablo Fiasco and Jason Brashil) literally incorporating Super_Collider was commissioned for this cover and for use at their live shows. This was then photographed by Dave Breckon from Red Design with Vogel and Lidell being incorporated into the shot. The photo of the piece seemed too garish to use on the cover so it was digitally toned down and chopped up using layers in Photoshop. This was then placed in a handmade border over a digital collage of photos of the graffiti piece being made and ephemera collected during a trip to Perth, Australia where Super_Collider had recently played. A densely overlaid muted textural feel was created using distortions of digital technology (fax machines, photocopiers, scanners) to echo the creation of the music. 'Considered Digital Chaos' – being the mission statement here.

TECHNIQUE / KIT

Graffiti artists Pablo Fiasco and Jason Brashil created a piece incorporating Vogel and Lidell in the artwork by spraying over them. This process and the final piece were photographed by David Breckon using a Nikon FG20 and Agfa Ultra film. These photographs along with some shots taken by Ed Templeton (using an Olympus mju-II), ephemera from a trip to Australia and a frame made from electrical tape were scanned and compiled in Photoshop. Song titles and borders were first created on the computer and printed out, then distorted by hand and fax machine and scanned back into Photoshop. The background collage was created by color, adjusting all the images to similar hues then laying them over one another in Photoshop. The image of the graffiti piece was distorted and fractured using layers in Photoshop. It was then placed inside the electrical tape border using the mask facility. Together with the tape mask this was then placed over the background collage. The song titles and outer border were turned into bitmap images and laid over the completed CMYK image in FreeHand along with the periphery text and logos.

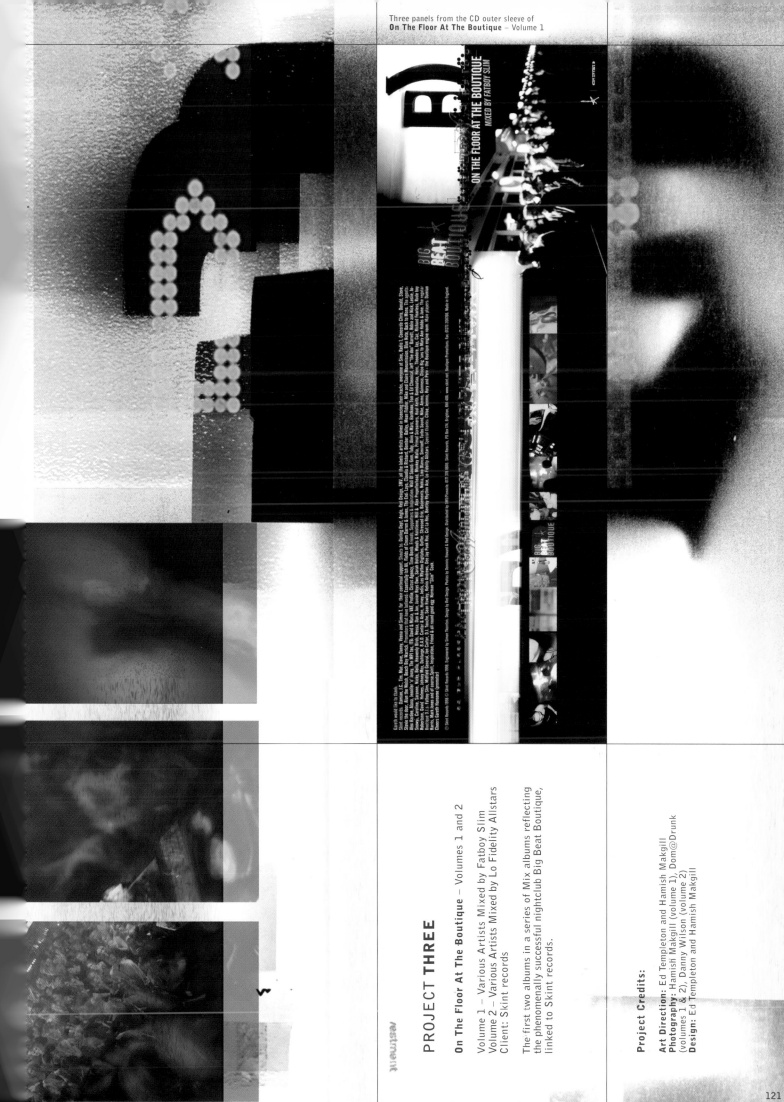

restraint

PROJECT THREE

On The Floor At The Boutique – Volumes 1 and 2

Volume 1 – Various Artists Mixed by Fatboy Slim
Volume 2 – Various Artists Mixed by Lo Fidelity Allstars
Client: Skint records

The first two albums in a series of Mix albums reflecting
the phenomenally successful nightclub Big Beat Boutique,
linked to Skint records.

Project Credits:

Art Direction: Ed Templeton and Hamish Makgill
Photography: Hamish Makgill (volume 1), Dom@Drunk
(volumes 1 & 2), Danny Wilson (volume 2)
Design: Ed Templeton and Hamish Makgill

DEVELOPMENT : **VOLUME 1:**

Red Design does all the publicity for Big Beat Boutique. Makgill and Templeton met with owners Gareth Hansome and Damian Harris and discussed ways to avoid falling into the club mix CD cliché of poorly photographed, scantily clad girls in a club. They wanted to capture the hedonism and excitement of the club but also to reflect its defiantly nonconformist nature. They thought a unique approach would be to concentrate on imagery and details that are often glossed over or ignored. The gritty, dirty, raw edge.

One thing that stood out to anyone who went to Big Beat Boutique in its original home at The Concorde in Brighton were the huge queues that built up hours before opening time. Red Design decided to focus on this as front cover imagery especially because the venue was due to shut down fairly soon after the album was released. Hamish shot the queue using an Eastern European camera made by Lomo which gives a fairly randomized yet dense, heavily saturated image, as well as taking some shots inside the club. Red Design also sent Dom to the club over several weeks with a brief to capture some unconventional un-staged shots of the club where any people captured were almost incidental. The neon sign for the club was shot on a separate occasion in a more controlled environment. The resulting photographs were very "un-photographic". Surrealistically colored images focused equally on the detritus of the club, as well as the clubbers themselves; once all the images were collected the shots to be used were selected and a layout containing imagery and typographic elements, as well as the club's neon logo were laid out in Photoshop. The images themselves were not doctored in Photoshop.

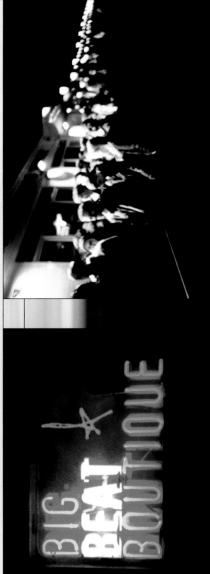

'We decided to take the title literally, concentrating on views "on the floor" at the Boutique, taking in beer glasses, fag-butts, club scum and the crowd's dancing feet.'

Three panels from the CD outer sleeve of **On The Floor At The Boutique – Volume 2**

DEVELOPMENT : **VOLUME 2:**

For the second volume in the series Red Design decided to take the title literally and concentrate on views "on the floor" at the Boutique, taking in beer glasses, fag-butts, club scum and the crowd's dancing feet. They commissioned Dominic Howard and Danny Wilson to spend an evening at the Boutique and capture a mixture of dancing feet and club detritus. Cigarettes and alcohol they certainly got, but for the image deemed most appropriate for the cover there weren't enough dancers in the photograph not very flattering for a club to seem to have an empty dance floor. To fix this situation Red Design combined another shot of dancing legs into the background to fill up the dance floor and they also added the star device (common to both Skint records and the Boutique) to the girl's trainers as a cheeky addition. Dominic also set up a fixed camera and took a series of shots throughout the night documenting the development from the empty club through to the end-of-night madness. Sets of speakers photographed by Hamish for the Boutique's new logo were also used and layered in Photoshop to echo the typographic devices on the first album. All of the chosen photographs were collated along with ephemeral material (bank letters, plastic wallets and post marks) and laid out in FreeHand 8.0 in a similar style to the first album.

123

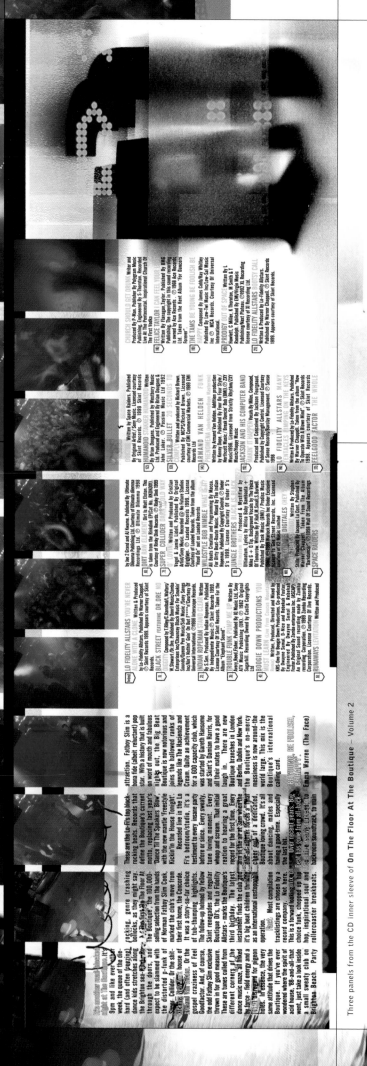

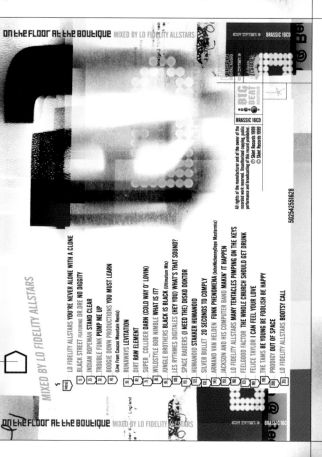

ON THE FLOOR AT THE BOUTIQUE MIXED BY LO FIDELITY ALLSTARS

BRASSIC 16CD

MIXED BY LO FIDELITY ALLSTARS

ON THE FLOOR AT THE BOUTIQUE MIXED BY LO FIDELITY ALLSTARS

BRASSIC 16CD

01 LO FIDELITY ALLSTARS YOU'RE NEVER ALONE WITH A CLONE
02 BLACK STREET FEATURING DR.DRE NO DIGGITY
03 INDIAN ROPEMAN STAND CLEAR
04 TROUBLE FUNK PUMP ME UP
05 BOOGIE DOWN PRODUCTIONS YOU MUST LEARN (Live From Caucus Mountain Remix)
06 RUNAWAYS LEVITATION
07 DIRT RAW ELEMENT
08 SUPER_COLLIDER DARN (COLD WAY O' LOVIN)
09 WILDSTYLE BOB NIMBLE WHAT IS IT?
10 JUNGLE BROTHERS BLACK IS BLACK (Ultimatum Mix)
11 LES RYTHMES DIGITALES (HEY YOU) WHAT'S THAT SOUND?
12 SPACE RAIDERS (I NEED THE) DISKO DOKTOR
13 HUMANOID STAKKER HUMANOID
14 ARMAND VAN HELDEN FUNK PHENOMENA (JohnNichomoJope Mastermix)
15 JACKSON AND HIS COMPUTER BAND MAKIN' IT HAPPEN
16 LO FIDELITY ALLSTARS MANY TENTACLES PIMPING ON THE KEYS
17 FEELGOOD FACTOR THE WHOLE CHURCH SHOULD GET DRUNK
18 FELICE TAYLOR I CAN FEEL YOUR LOVE
19 THE TAMS BE YOUNG BE FOOLISH BE HAPPY
20 LO FIDELITY ALLSTARS BOOTSY CALL
21 PRODIGY OUT OF SPACE

TECHNIQUE / KIT Volumes 1 and 2

For both of these projects, Red Design tried to achieve the atmosphere of the work through the photography rather than digital techniques, using Photoshop mainly as a tool for compiling and interacting with the images. Although some image manipulation was necessary — the star logo imposed on the trainer and the extra dancers in the background on the second album as well as the type and speaker devices (blurred and overlaid) that appear on each album respectively — for the most part it was their intention to keep the integrity of the original photographs intact.

art of

UK

WORKING WITH PHOTOGRAPHY

'After initial meetings and briefings with clients and artists (often fairly ambiguous and open) we will regroup and brainstorm ideas until fairly distinct visual and typographical ideas are formed. With regards to the proposed photography we then decide which images we already have (in our collective libraries of images), which we can shoot ourselves, or which we should commission one of the handful of photographers we regularly use. Outside of commissioned photography we sometimes use image-banks like Photodisc for images we can't achieve due to locations and/or budget and we also like using found imagery from old books/magazines etc. – rubbish essentially. Often our work comprises of several of these resources together, either through traditional cut-and-paste collage techniques or digitally collaged techniques. Manipulation of photographs is dependent on the quality of the original image and our desired effect of those images. We manipulate manually as well as digitally using all manner of substances and liquids to achieve desired effects. Our main use of digital manipulation is in Photoshop to montage/collage images using masks, cut-and-paste techniques and layer interaction functions,' they explain.

'We only really tamper with the make-up of the images if it is essential to the idea (i.e. Super Collider) or if time and/or budget won't stretch to the desired shoot or a reshoot if a particular look isn't achieved initially,' they explain.

HARDWARE (Computer):

PowerMac G3/400 256 megs of RAM
Macintosh 8600/200 (upgraded to G3/400) 352 megs of RAM
Macintosh 7500/100 (upgraded to 233Mhz) 192 megs of RAM
Macintosh 7100/66 128 megs of RAM
One 14" Apple Monitor
Two 17" Applevision Monitors
One 21" Applevision Monitor
Linotype Hell Scanner (with transparency hood)
Epson Stylus Photo 1200 Color Inkjet Printer
Texas Microlaser Powerpro Laser Printer
Samsung SF 5800 Laser Fax Machine

SOFTWARE (Computer):

Adobe Photoshop 5.0
Macromedia FreeHand 8.0
Poser 4.0

HARDWARE (Photography):

Nikon FG20 – Agfa Ultra film
Nikon FG – Fuji Velvia/Pravia film
Polaroid 600
Olympus mju-II
Lomo 35mm Camera
Matahari P-116 8mm Projector

HARDWARE (Essential):

AKAI AA-11 Amplifier
Teac U340 Cassette Deck
Dual CS616Q Turntable
Kenwood DOF-2010 CD Player
Tannoy Speakers

Magazine advertisement for **On The Floor At The Boutique** – Volume 1

Red Design
1.1, 1.2, 1.3,
11 Jew Street
Brighton, BN1 1UT, UK

Telephone: +44 1273 704614
Fax: +44 1273 704615
E-mail: reddesign@pavilion.co.uk
Website: www.red-design.co.uk

SEE PAGE 155

Client List:
Skint Records, Loaded Records, Download, Estereo Recordings, The End, XL Recordings, Talkin' Loud records, Manifesto, Mercury Records, Sony, Ultimate Dilemma.

michael spiccia

michael spiccia

sport - computer games

MICHAEL SPICCIA graduated in 1997 from The Western Australian School of Art and Design with a diploma in Art and Design, after which he ventured into the workplace in Perth with strong influences ranging from David Carson to Chris Ashworth and The Attik. Spiccia's design style continues to develop in its own right. The work he is mainly known for is the front covers of a publication called 'Hype' magazine which is a weekly street press distributed throughout Western Australia. At the end of June 1999 Michael Spiccia moved on to join The Attik in Sydney where he will further his design career. Particular future areas that he wants to pursue and specialize in are graphics for film broadcast, as well as print.

nightlife - fash

www.hyperm

entertainm

hype
magazine

nightlife · fashion · live music · dance · R+B · film · sport · computer games

Slim
Or Fat

FAT BOY
SLIM FAT BOY SLIM FAT BOY SLIM
FAT BOY SLIM FAT BOY SLIM FAT BOY SLIM FAT BOY SLIM
FAT BOY SLIM FAT BOY SLIM FAT BOY SLIM FAT BOY SLIM FAT BOY SLIM FAT BOY SLIM FAT BOY SLIM FAT BOY SLIM FAT BOY SLIM FAT BOY SLIM FAT BOY SLIM FAT BOY SLIM FAT BOY SLIM FAT BOY SLIM FAT BOY SLIM FAT BOY SLIM FAT BOY SLIM FAT

FAT BOY SLIM

A TRIBE CALLED QUEST
DJ SHINKAWA

NOW AVAILABLE AT **Only M**

Wednesdays Free Issue 16 ~ November 25 _ December 9

Perth's **FREE** entertainment guide

www.hypemag.com.au

THE PROJECT

Various Covers For **Hype** Magazine

BACKGROUND / BRIEF

On the debut of 'Hype' magazine the key element highlighted in the brief was "originality"; this was the stage set for the launch of the new publication. In order to achieve this task the magazine had to have a design style to reflect its uniqueness. Overall the look of the publication is quite youth-orientated but still has a corporate level to it, as its target audience are young adults between the ages of 18–28 years. The magazine is Perth's premier free entertainment guide which covers all the latest pubs, clubs and events happening around Perth as well as all the latest in music and film. Today 'Hype' magazine still comes from the same initial philosophy and has started to become a popular, influential and leading publication in Western Australian society.

Project Credits:

Art Direction and Design: Michael Spiccia
Photographers: Various Supplied Photographs
3-D Type Treatment: Jerome Truttman

'I have been doing covers for **Hype** since day one which gave it its feel and identity right from the start.'

DEVELOPMENT

Michael Spiccia's relationship with the creators of 'Hype' (publisher Jamie Huber, editor-in-chief Daniel Stinton, Christian Tinelli, Adam Castelli and Keith Addis) is a result of a friendship which existed previous to the magazine's conception. Spiccia was brought in as art director when the initial concepts for the magazine were being discussed and he played a key role in these early developmental stages. Once the magazine was launched there would be frequent meetings throughout the weeks to discuss the brief and decide how far to take the covers. It would then be up to Spiccia to adapt the information and merge it into the design style that 'Hype' is known for. The cover designs initially started off a bit lightly to ease into the market, but as momentum gathered each cover grew stronger in style and character. Spiccia has been doing covers for 'Hype' since day one and is responsible for giving the publication its feel and identity. Although his main focus is on the cover artwork, he also oversees the general feel of the magazine and is called on to design the higher profile feature spreads.

'Once I'm issued with the photograph which is to be used for the cover that's when my design development starts.'

As Spiccia comes to start on a clean canvas each week, he is briefed beforehand on who the cover will feature. Who or what is to be depicted influences the style which he hopes will best reflect the subject matter. For example, one issue had the band Silverchair featured on the front cover so the design style portrayed a deconstructivist grunge feel. Whereas another issue had the winning model of the 'Buttnaked' competition and Spiccia chose a more elegant style while still maintaining a "progressive" style. Once the cover photograph is issued, Spiccia's design process starts. As he pictures the photograph in his head he always draws up thumbnails that are kept in front of him so he can adhere to the general feel and layout that he had initially intended. From the initial thumbnail, he proceeds to execute the concept on the screen using the respective programs.

TECHNIQUE / KIT

Once the basic graphics and line work are constructed in FreeHand they are exported into the working Photoshop file as FreeHand EPS files. Although FreeHand is used extensively for Spiccia's designs, Photoshop is the key factor and main emphasis of his design process. The Photoshop layers and their functions (such as overlay, hard light, multiply, screen, etc.) are used to their fullest potential for each of the covers Spiccia is designing. 'As each layer is placed upon one another, that is when you start to see the design fall into place. It is quite an intense process, but that is what is required if you want a detailed multilayered piece of design. It's those finishing touches at the end that give it that extra edge,' says Spiccia. Alterations to the original photographs are mainly restricted to simple color manipulations such as using hue/saturations and various blur filters applied with the layer functions. Once the piece is satisfactorily completed, the Photoshop file is then "flattened" and saved as a TIFF file ready to be placed into Quark (where extra type is also added) for print.

As well as the basic techniques used to create the covers, there were additional techniques that added to the project. Primarily a photocopier which played an important role as a crucial tool in producing organically distressed effects to the type and graphics. The photocopied acetate sheets would then be scanned to be further manipulated in Photoshop. This procedure was key, especially when it came to the type. It provided flexibility to do a lot of cut and pasting and experimenting with different letterforms. This merging of different kinds of letterforms applied to a variety of imagery adds to 'Hype''s unique style and image.

hype magazine

Perth's FREE entertainment guide
ISSUE 19 - 14.1.99

BUTTNAKED
SENSATIONAL SUMMER GIRL SERIES 1998

WINNER
ALI MUTCH

BUTT NAKED

SENSATIONAL SUMMER GIRL
SERIES 1998

WINNER
ALI MUTCH
Ali Mutch

SOFTWARE (Computer):

Macromedia FreeHand 7.0
Adobe Photoshop 5.0
QuarkXPress 4

HARDWARE (Computer):

PowerMac G3 with 17″ Apple Monitor
USB Mouse and Zip Drive
128 megs of RAM with 6 gig Hard Drive

Michael Spiccia
3 Hornet Rise, Willetton
6155, Western Australia

Telephone: +61 8 9332 6740
E-mail: msdesign@opera.iinet.net.au or michael.spiccia@theattik.com
Alternatively contact: The Attik (Sydney, Australia)

SEE PAGE 156

Client List:
'Hype' magazine, Brooking Design Practice, Live Clothing, Street
Design, Barbagallo Water Sports, Burswood Casino, Metropolis
Concert Club, Krush, Global Hair, Sony Music.

why not associate
Why Not
Why Not associates

SOHO 601

SIX ⬦ ⬦O ONE ⬦ SIX O SIX O ⬦ 6O-11 1ONE ONE ⬦ 6 SIX SIX O ONE
6O ONE ⬦ SIX ⬦ ⬦ ⬦ SIX O ⬦
SOHO 601

SOHO 601 71 DEAN STREET LONDON W1V 5HB TEL +44 171 439 2730 FAX +44 171 734 3331

UMATIC **SHOWREEL**

WHY NOT ASSOCIATES

were established in 1987. From the outset it was conceived as a multi-disciplinary design partnership with the belief that its vision and ideas could be applied to a wide range of media. This spirit of optimistic experimentation has led to projects ranging from exhibition design to postage stamps via advertising, publishing, television titles and corporate identity. In the process Why Not Associates have proved that people are a lot more receptive to adventurous design than they are sometimes given credit for and that such work need not be limited to the "ghettos" of youth culture and arts projects. Handled with confidence, such work can be successful at every level.

The partnership now comprises of five designers: Andy Aaltmann, David Ellis, Patrick Morrissey, Iain Cadby, Mark Molloy and a great deal of computer equipment housed in an office in the centre of Soho in London.

The majority of the current work is still print based although the studio's design work for television and the web is steadily increasing. The linking factor in all these media is the understanding of communication. Indeed, it is their skill as visual communicators which tends to lift their work beyond the various media that carry the message.

Whilst their aim is to offer new solutions to age-old problems of communication, design and marketing; their prime concern is to make them work coherently and commercially for the client. The output is amazingly varied, but what links it all is the clients' willingness to share a spirit of adventure and invention.

SOHO 601

SOHO 601 71 DEAN STREET LONDON W1V 5HB TEL +44 171 439 2730 FAX +44 171 734 3331 WEB www.sohogroup.com

SOHO 601

THE PROJECT

soho 601 company identity

THE BRIEF

Located in Soho, London, soho 601 is a post-production company specializing in editing and adding special effects to film. Why Not Associates' sister company Why Not Films does a lot of post-production there on various promo and adverts. This lead to them being asked to redesign soho 601's company identity.

When asked if 601 had any influence over the design of their company's identity, Why Not answered with a simple, "no". They were given complete freedom to create soho 601's identity.

Editors sift through hours of film from which only a few moments are chosen, this idea of moving film and scrutinizing a special particular moment is the metaphor Why Not have visualized with the aid of stock photography. Why Not didn't want to approach this project in the typical manner of designing a logo and sticking it in the corner of everything (i.e. letterhead, compliments slip, business card, labels, etc.), it may be a quick solution each time you need to design something new but it's not very imaginative. This system of using different images and type on each piece not only made it more challenging for Why Not to design, but it's also far more interesting for the people who have the pleasure in using it. The type seemingly looks different for each piece but on closer inspection it is always the same elements in a different composition, this is the beauty of a flexible visual system. Once you are familiar with this idea you recognize and are surprised with each new piece.

Project Credits:

Andy Altmann
David Ellis
Patrick Morrissey
Iain Cadby

Photodisc

SOHO 601

SOHO 601 71 DEAN STREET LONDON W1V 5HB
TEL +44 171 439 2730 FAX +44 171 734 3331 WEB www.sohogroup.com

[HENRY ELLIS MANAGING DIRECTOR]

Business card

Showreel insert

'We don't design a logo and stick it in the corner of everything.'

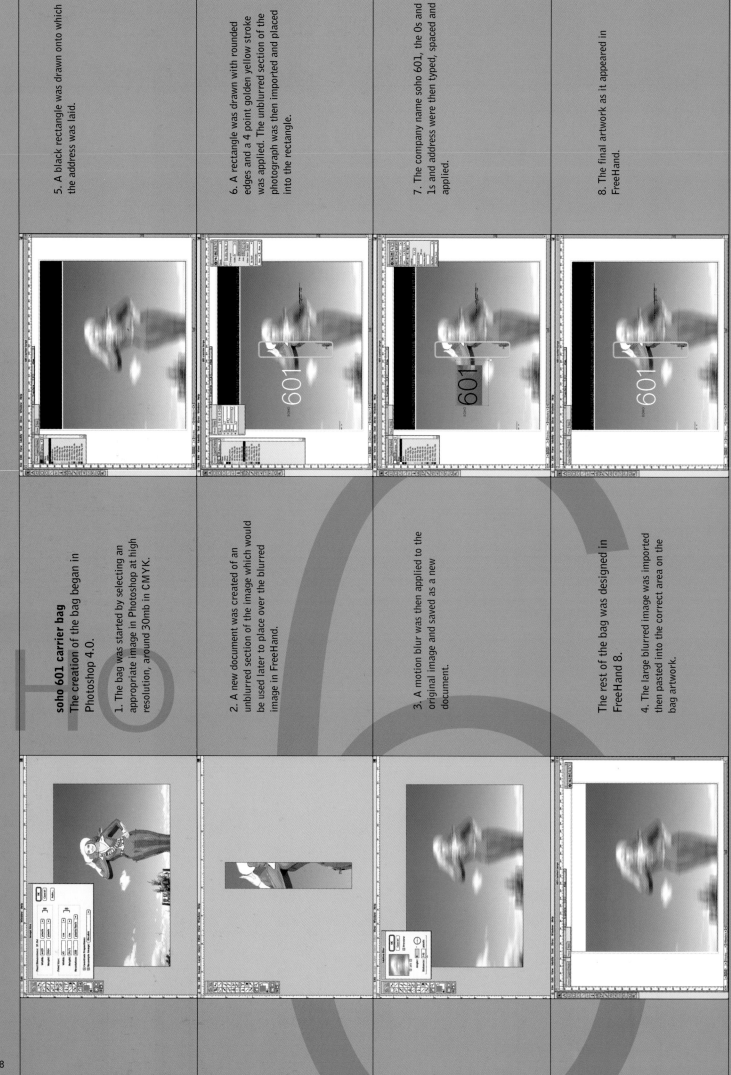

soho 601 carrier bag

The creation of the bag began in Photoshop 4.0.

1. The bag was started by selecting an appropriate image in Photoshop at high resolution, around 30mb in CMYK.

2. A new document was created of an unblurred section of the image which would be used later to place over the blurred image in FreeHand.

3. A motion blur was then applied to the original image and saved as a new document.

The rest of the bag was designed in FreeHand 8.

4. The large blurred image was imported then pasted into the correct area on the bag artwork.

5. A black rectangle was drawn onto which the address was laid.

6. A rectangle was drawn with rounded edges and a 4 point golden yellow stroke was applied. The unblurred section of the photograph was then imported and placed into the rectangle.

7. The company name soho 601, the 0s and 1s and address were then typed, spaced and applied.

8. The final artwork as it appeared in FreeHand.

Back of carrier bag

Front of carrier bag

'We used stock photography over taking the pictures ourselves for a number of reasons, this was one of the first times we used stock photography and Photodisc's huge library meant we could really choose and experiment with photographs we otherwise would not have access to.'

Two variations of Beta video sleeve labels

'In the past the problem with stock photography is it looked so much like stock photography, nowadays you can get almost any kind of image you want, of course if you have anything too specific in mind you have to shoot it yourself!'

'You can be as creative with the right stock photograph as with something you have shot yourself, it really depends on what you are doing.'

Carrier bag

HARDWARE (Computer):

PowerMac G3
Apple Colour Sync Monitors

SOFTWARE (Computer):

Adobe Photoshop 5
Macromedia FreeHand 8
Adobe AfterEffects 4

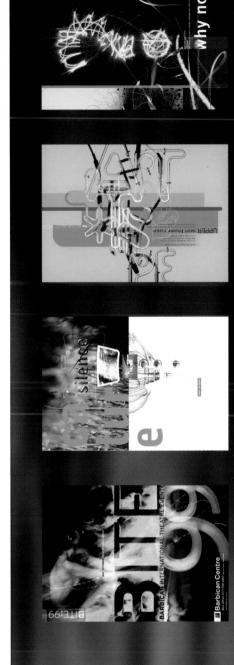

why not associates
Studio 17, 10–11 Archer Street
London, W1V 7HG, UK

Telephone: +44 207 494 0762
Fax: +44 207 494 0764
E-mail: whynot@easynet.co.uk

SEE PAGE 157

Client List:

The Next Directory, The Royal Mail, Smirnoff,
EMI Records, Island Records, A&M Records,
BBC, The Pompidou Centre, Adidas, Virgin Records.

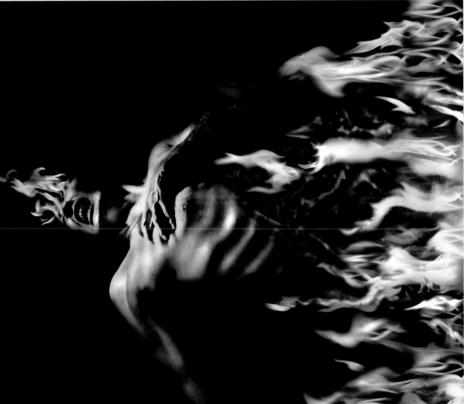

Anthony Artiaga 10644 Hatteras Street, North Hollywood, California 91601, USA
Telephone: +1 818 505 0849 Fax: +1 818 760 4231 E-mail: artiagarose@worldnet.att.net.

Client List: Sony Music, 'Rolling Stone' (USA), Warner Bros. Records, 'RayGun' (USA), Paramount Pictures, Microsoft.

1
Liberty Lady
Personal work

2
Flame Head (anti-methamphetamine poster)
Client: HIDTA

3
Baseball Head
Advertisement for the video game 'Doom II'

4
Valve Head
Image created for a migraine headache relief product

Margo Chase Design

Margo Chase Design 2255 Bancroft Avenue, Los Angeles, California 90039, USA
Telephone: +1 323 668 1055 Fax: +1 323 668 2470 Website: www.margochase.com

Client List: Columbia Pictures, Paramount Pictures, Warner Bros., Nike, Reebok, Adobe Systems, The Hard Rock Hotel, Microsoft Network.

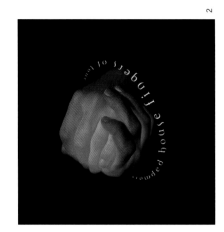

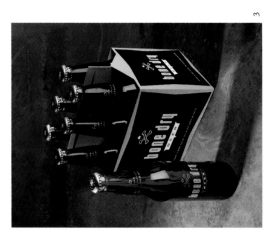

1 Desire Book (blank gift cards, journal, mini book)
 Client: Chronicle Gift Works

2 Crowded House 'Fingers Of Love' (CD single sleeve)
 Client: Capitol Records

3 Bone Dry Beer (packaging)
 Client: Rod Bone

4 Gatta Snowboard (part of the California Disaster series)
 Client: Yonex (Japan)

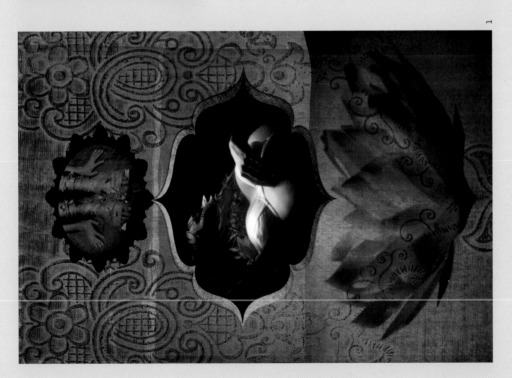

1	'Holy Smoke' by Jane & Anna Campion (book cover) Client: Miramax Books. Designer: Christine Weathersbee

2	Levi's 'Trophy' Client: Levi's Advertising Agency, Foote, Cone & Belding

3	Environment (editorial piece created for 'Time' magazine, Latin America) Client: 'Time' magazine. Art Director: Edel Rodriguez

4	'The Wasp Factory' by Iain Banks (book cover) Client: Random House Books. Designer: Dan Rembert

Amy Guip 91 East 4th Street, 6th Floor, New York City, New York 10003, USA
Telephone: +1 212 674 8166 Fax: +1 212 674 2775 E-mail: guip@earthlink.net
Representative: Kathleen McCormack at AKA Reps. Telephone: +1 212 620 4777 Fax: +1 212 620 4888 E-mail: akareps@earthlink.net

Client List: Coca-Cola, Reebok, Nike, Levi's, IBM, MTV Networks, Showtime, 'Time' (Latin America), Random House, Sony Music and Warner Bros. Music.

Client List: Capitol Records, EMI, Roadrunner Records, RCA, Columbia, Electra
Epic Records, Nothing/Interscope, Def Jam Recordings, Sony, Virgin International.

Dean Karr P.O. Box 691335, West Hollywood, California 90069, USA
Teleponе: +1 310 917 3686 Contact: Yamani Watkins
E-mail: granfinger@aol.com Website: www.mkgallery.com

Dean Karr

1 Duran Duran 'Out Of My Mind' (video)
 Client: Virgin International

2 Tool 'Undertow' (CD package)
 Client: Zoo Entertainment

3 Amen 'Amen' (CD package)
 Client: Roadrunner Records

4 Duran Duran 'Out Of My Mind' (video)
 Client: Virgin International

5 Marilyn Manson 'Anti Christ Superstar'
 Client: Nothing/Interscope Records

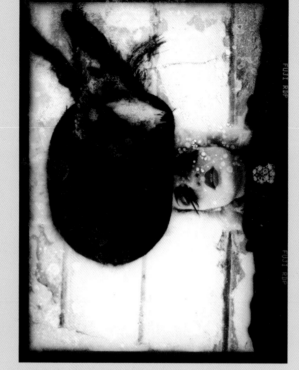

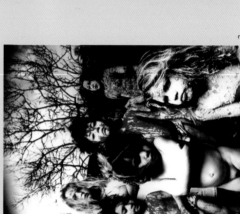

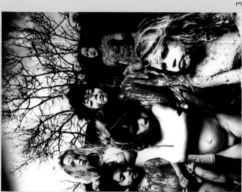

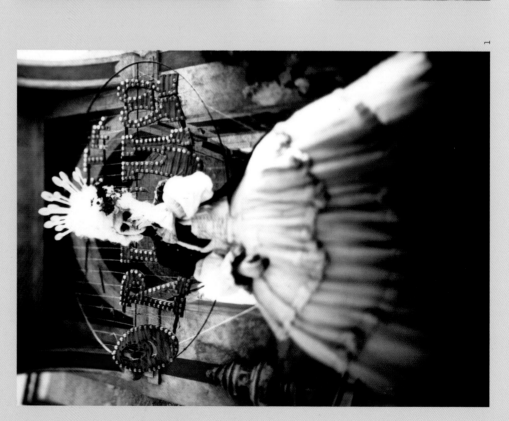

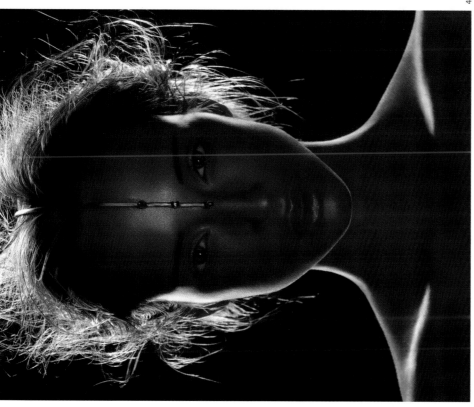

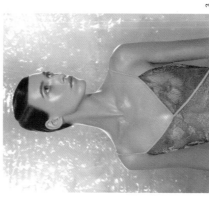

Markus Klinko and Indrani Pal-Chaudhuri

Representation: Mutale Kanyanta, Art department, 48 Green Street, 4th Floor, New York City, New York 10013, USA
Telephone: +1 212 925 4222 Fax: +1 212 925 4422 E-mail: markusk@earthlink.net Website: www.klinko.com

Client List: 'Interview' (USA), 'Vibe' (USA), 'People' (USA), 'GQ' (UK), 'Arena Homme Plus' (UK), Sunday Times 'Style' (UK), 'French Max', 'Stern' magazine (Germany), 'International Harper's Bazaar' and Electra Records.

1
Editorial work
'Stern' magazine (Germany)

2
Editorial work
Isabella Blow's Sunday Times 'Style' (UK)

3
Editorial work
'Interview' magazine (US)

4
Personal work

Designbureau KM7 Schifferstrasse 22, D-60594 Frankfurt, Germany

Telephone: +49 69 96 21 81 / 30 Fax: +49 69 96 21 81 / 22

E-mail: Klaus.Mai@frankfurt.netsurf.de Website: www.km7.de

Client List: Audi, Swatch, Volkswagen, Universal Music, Sony Music, Nike.

Klaus Mai

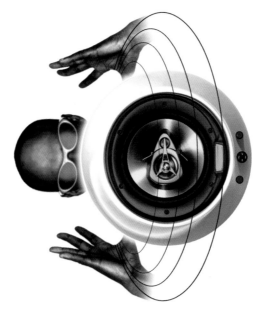

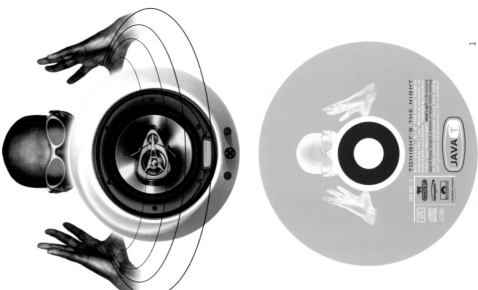

1 Java T 'Tonight's The Night' (CD sleeve and label)
Client: Polydor/Zeitgeist/What's Up?!

2 Animatated On-Air-Design for MTV
Client: MTV

3 Dog illustration for Swatch's new 'Internet Time' watch
Client: Swatch Watches

4 Milkglass (one of a series of glasses each by different designers)
Client: Ritzenhoff

第廿三屆香港國際電影節
The **23**nd Hong Kong International Film Festival

Film

3.31 — 4.15

建設勿略環保　自然走上絕路

加強環保意識　留住生態本色

1　Environmental Protection (poster)

2　'IDN' magazine (cover)

3　Mobile Phone Advertisement (poster)

4　Hong Kong International Film Festival (poster)

Jerry Lee Production Studio, Flat A, 9/F, Po Ming Building, 2 Foo Ming Street, Causeway Bay, Hong Kong
Telephone: +852 2890 8773 or +852 2895 1536 Fax: +852 2576 1085
E-mail: jerry2c@hkstar.com or jerry@hkipp.org

Client List: Grand Hyatt Hotel, Johnson & Johnson (HK), Pizza Hut, Motorola, Standard Chartered Bank, Chase Bank, 3M (HK), Fuji Photo Products, Mobil Oil (HK), Hong Kong Post Office.

Catherine McIntyre 8 Park Avenue, Dundee, DD4 6PW, Scotland, UK

Telephone: +44 1382 458 083 Fax: +44 1382 860 907 E-mail: c.mcintyre@cableinet.co.uk

Website: wkweb5.cableinet.co.uk/c.mcintyre/home.html

Client List: Bridgewater Book Company, Godsfield Press, Focal Press, RotoVision, Ivy Press, the University of Dundee and the University of St Andrews, 'The Scotsman' (UK).

catherine McIntyre

1	2	3	4	5
Accounts	Lies, Damned Lies And I Love You	Sealed	Woman Of Letters	Urban Angel
Personal work	Personal work	Personal work	Personal work	Personal work

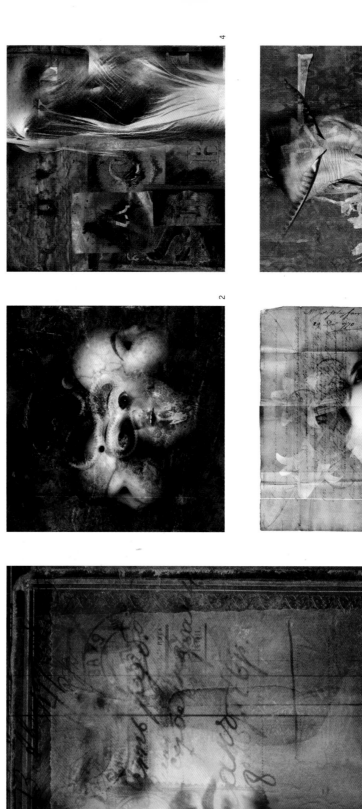

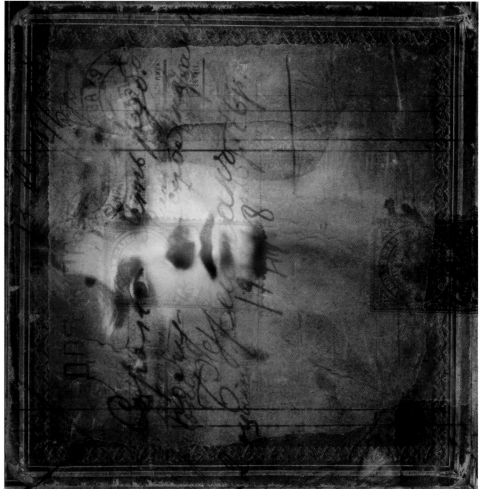

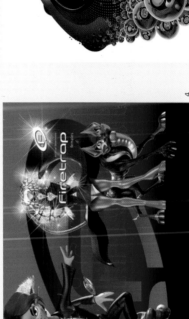
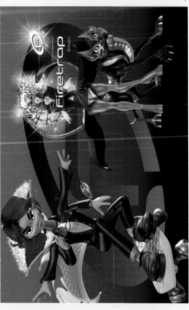

1	'Pin Up' Advertising campaign Client: Diet Coke
2	Menswear double page advertisement Client: Firetrap
3	Summer Sale ad campaign for Tokyo Store Client: Laforet, Japan
4	Womenswear double page advertisement Client: Firetrap
5	Watch Launch ad campaign Client: Wieden & Kennedy/Nike

Client List: Apple, Cellnet, Björk, Fuji, Sony, Camel, Nike, Diet Coke, Aprillia, Firetrap, Laforet.

Me Company 14 Apollo Studios, Charlton King's Road, London NW5 2SA, UK

Telephone: +44 207 482 4262 Fax: +44 207 284 0402

E-mail: info-axis@mecompany.com Website: www.mecompany.com (Online Portfolio)

Kelvin Murray St Lukes Hall, 120 Fortune Green Road, London NW6 1DN, UK
Telephone: +44 207 431 5414/5 Fax: +44 207 435 5315 Mobile: 07050 130130
E-mail: Kelvin@Kelvinmurray.co.uk Website: www.kelvinmurray.co.uk

Client List: Gordon's Gin, Durex, Dunhill, Hewlett Packard, Wella Hair, Scottish Widows, Mulberry, Renault, Camel, Bacardi, Bosch, Garnier, State Express 555, Technics.

kelvin Murray Kel

4

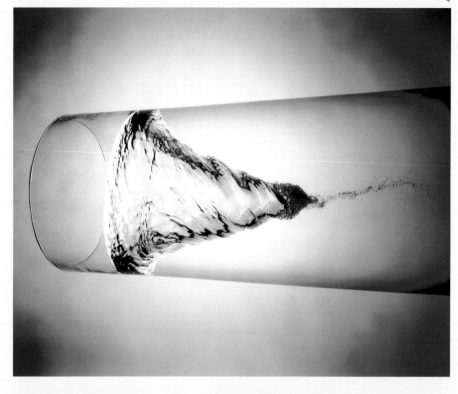

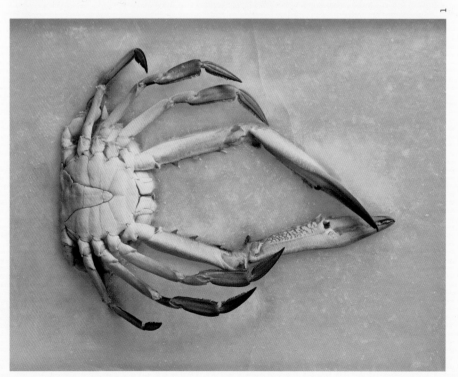

1
Crab
Personal work

2
Commercial work
Client: Danka Copiers

3
Commercial work
Client: Dunhill

4
Vortex
Personal work

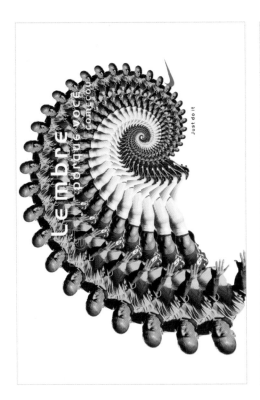

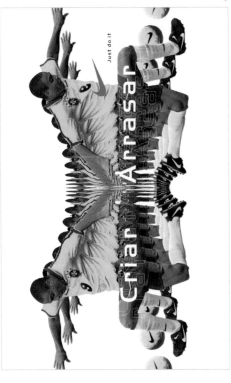

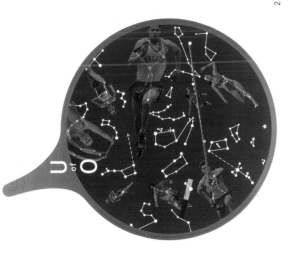

Robert Nakata Wieden & Kennedy, Keizersgracht 125–127, 1015 CJ Amsterdam, the Netherlands

Telephone: +31 20 621 3100 Fax: +31 20 621 3299

E-mail: robertn@wkamst.nl

Client List: (Wieden & Kennedy worldwide) Nike, Audi, Miller Beer, HypoVereinsbank, ESPN, Coke, Brand Jordan, Oregon State Tourism.

1 Nike sponsored event (poster)

2 Nike sponsored event (poster)

3 Benelli print campaign
Client: Benelli Scooters and Motorcycles

4 Nike football campaign
Two of four advertisements for Brazilian Football

one9ine 54 West 21st Street, Suite 607, New York City, New York 10010, USA
Telephone: +1 212 929 7828 Fax: +1 212 645 3409 E-mail: warren@one9ine.com | matt@one9ine.com
Website: www.one9ine.com

Client List: 'GQ' (UK), Condé Nast, 'House & Garden' (UK), 'Esquire' (UK),
MTV, 'RayGun' (UK), Apple, The American Lung Association, Toshiba, 'National
Geographic', Altoids.

1 WHYX postcard
 Client: Warren Corbitt

2 Aviation (screen grab from VolumeOne website)
 Client: Matt Owens (VolumeOne)

3 Shoe (2000 years of sports concept illustrations – one of four)
 Client: ESPN magazine

4 'IDN' magazine cover
 Client: International Designers Network

Red Design

Red Design 1.1, 1.2, 1.3, 11 Jew Street, Brighton, East Sussex, BN1 1UT, UK

Telephone: +44 1273 704 614 Fax: +44 1273 704 615

E-mail: reddesign@pavilion.co.uk Website: www.red-design.co.uk

Client List: Skint Records, Loaded Records, Download, Estereo Recordings, The End, XL Recordings, Talkin' Loud records, Manifesto, Mercury Records, Sony, Ultimate Dilemma.

1 Lo Fidelity Allstars 'How To Operate With A Blown Mind' (Album Sleeve)
 Client: Skint Records

2 Urban Species 'Woman' (CD Single Sleeve)
 Client: Talkin' Loud/Mercury Records

3 Karen Ramirez 'Distant Dreams' (CD Album Sleeve)
 Client: Bustin' Loose Recordings/Mercury Records

4 Fat Boy Slim 'You've Come A Long Way, Baby' (Album Sleeve)
 Client: Skint Records

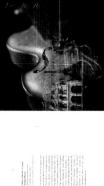
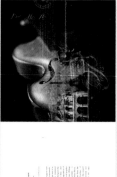
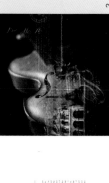
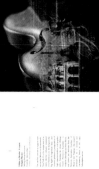
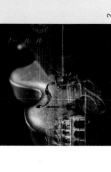

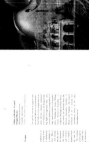
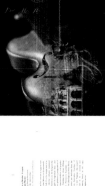

Michael Spiccia 3 Hornet Rise, Willetton 6155, Western Australia

Telephone: +61 8 9332 6740 E-mail: msdesign@opera.iinet.net.au or michael.spiccia@theattik.com

Alternatively Contact: The Attik (Sydney, Australia)

Client List: 'Hype' magazine (Australia), Brooking Design Practice, Australia, Live Clothing, Street Design, Barbagallo Water Sports, Burswood Casino, Metropolis Concert Club, Krush, Global Hair, Sony Music.

1 In-store Promotion proposal
 Client: Live Clothing

2 1999 Subscription series brochure (created at Street Design)
 Client: University Music Society

3 Folder and brochure (created at Street Design)
 Client: Perth Education City

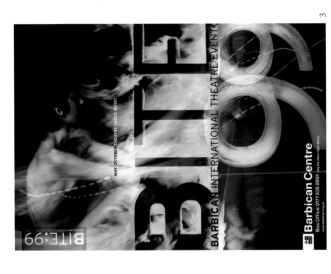

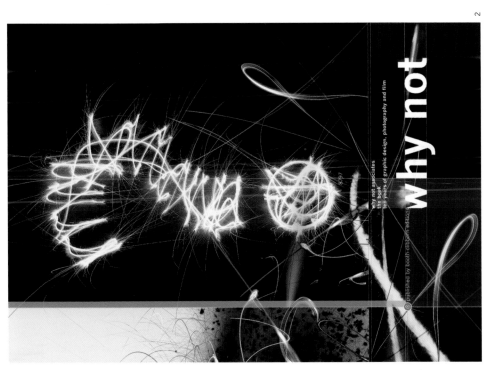

1
Magazine cover
Client: Upper and Lowercase

2
Poster
Why Not Book promotional poster

3
Poster
Client: Barbican Theatre

4
Divider pages
Client: Shots Diary

why not associates Studio 17, 10–11 Archer Street, London, W1V 7HG, UK

Telephone: +44 207 494 0762 Fax: +44 207 494 0764 E-mail: whynot@easynet.co.uk

Client List: The Next Directory, The Royal Mail, Smirnoff, EMI Records, Island Records, A&M Records, BBC, The Pompidou Centre, Adidas, Virgin Records.

acknowledgements

First and foremost an enormous thanks to all the photographers and designers who contributed to this book, your generosity and inspiring insights will never be forgotten. Another enormous thanks to Kate Noël-Paton and Natalia Price-Cabrera at RotoVision for your patience, understanding and unwavering faith in my abilities to pull off this project. And my RotoVision thanks would not be complete without thanking John Clifford for letting me design this book in Macromedia's FreeHand (which probably saved two months of extra work) and Simon Hennessey for seeing me through the finer technical details. A deep and heart-felt thanks to my better half Dana Maria Gingras for unselfishly letting me continuously share my thoughts about this project and for sacrificing an incredible amount of our "quality time" together. This book is dedicated to my two sons, James Gray Gilmore and Marcus John Gilmore.